creative wood letters

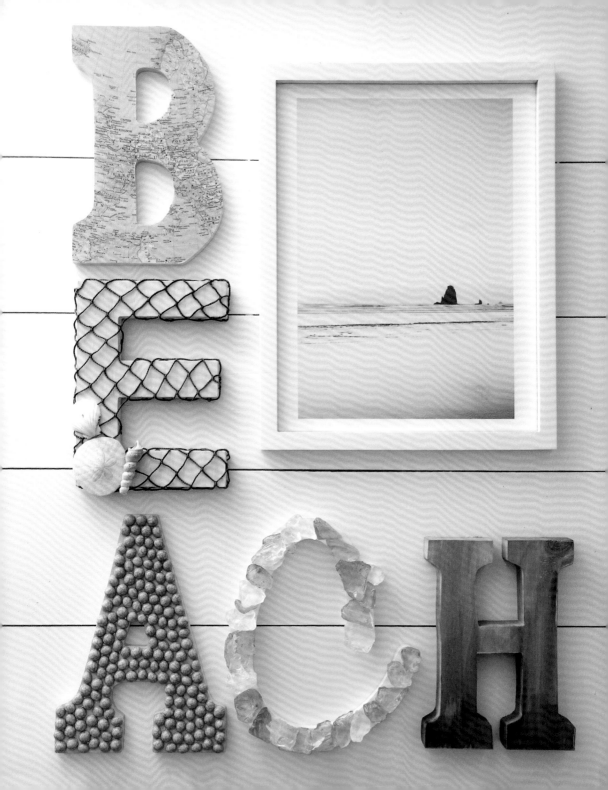

creative wood letters

SIMPLE CRAFT PROJECTS
FOR DECORATING YOUR HOME

Krista Aasen

WATSON · GUPTILL
CALIFORNIA | NEW YORK

CONTENTS

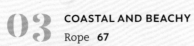

introduction

You've probably spotted wood letters everywhere lately, perhaps because letters have such meaning for people. Few symbols have as much meaning as those letters that are personal to you or your family and that resonate with you, whether they represent a name, place, or word. In addition, a rising interest in typography has shone the spotlight on letters for their design qualities alone, making wood letters one of the most personal décor and craft trends out there.

But where can you use letters? How do you decorate with them? Wood letters look amazing displayed on bookshelves or used in decorative vignettes. Our living room bookcase features several letter A's done in different styles, all of which work with our overall beachy and airy decorating style. We chose the letter A because it is the first letter of our last name. Another option might be to select the first letters of the first names of everyone in your family, or other special words or place names.

In addition to decoration on shelves, mantels, and sideboards, letters look beautiful displayed on walls. Large wood letters add a graphic punch to a small wall all on their own, or you can add smaller wood letters to a gallery wall display. They can be used in living rooms, family rooms, hallways, bedrooms, craft rooms, laundry rooms, and playrooms, spelling out general words like *love, calm,* and *hello;* nouns like *pantry* and *Paris;* and numbers and symbols like *123,* &, and *XOXO.* I've even seen the first letter of a family's last name in multiple styles massed together to create a graphic feature wall in the foyer.

Decorative wood letters can also make incredible gifts. They are a creative way to welcome a new baby with custom nursery décor. You can tailor letters to the interests of any child or teen, whether they love comic books, sports, flowers, or butterflies. In fact, there's a way to customize a wood letter for everyone. Not only for babies and children, wood letters can be crafted as fabulous gifts for grown-ups as well: friends, hosts, teachers, or coworkers—even Mom or Dad, Grandma or Grandpa. Because wood letters can be styled in so many unique

and interesting ways, they are truly one of the most versatile craft and décor trends out there—simple, personal, interesting, and graphically beautiful. It's hard to go wrong with wood letter craft!

I've organized this book into five different chapters, each with a specific theme. There are chapters on special paint finishes and a variety of other styles: rustic and farmhouse, beachy and coastal, cute and cheery, and pretty and glam. Within each chapter, I share seven different projects that are loosely related to the design style under which they are grouped and that will suit a range of ages and tastes. I provide some suggestions for the uses of each style of letter, as well as various words that they might be suited to spelling. But the ideas contained in these pages are really just a springboard. As the crafter and creator, you are limited only by your imagination. Take the ideas you find here and follow them to the letter (pun intended), or use them to branch off and develop your own unique angle. Whatever approach you take, you can't go wrong, and the people for whom you create these letters are sure to love them!

CHOOSING YOUR LETTER FONT

There are so many font styles and sizes available when it comes to wood letters. You will want to select font styles and sizes that work well with the material you plan to apply to the letter. Less angular materials, such as buttons, flowers, felt balls, or shells, suit a more fluid or cursive font style quite nicely; a manuscript-style letter works well for materials that are straighter, like rope or paper straws. I have made recommendations in each project about the font style that will likely be easiest to use. But ultimately, you can adapt almost any design to whichever font you like best.

BUYING SUPPLIES

Wood letters are available in most craft stores and several big-box stores (including Michaels, Jo-Ann, Hobby Lobby, and Target) or through online retailers such as craftcuts.com. Just search online for "unfinished wood letters" or "wood letters" to find additional fonts, styles, and sources.

I bought nearly all of my supplies and materials for this entire book at my local craft store. When I refer to craft paint, I am referring to the

small 2-ounce jars of acrylic craft paint available in craft stores and in the arts and craft section of many big-box department stores. I recommend Martha Stewart, DecoArt, FolkArt, and Plaid brands. I used general-use or multi-purpose synthetic-bristle craft paintbrushes.

I ordered a few items online through Etsy, such as the felt balls and the printable downloads of graphic papers to use in some of the découpage letter designs. I also ordered some of the specialty paint, such as the Modern Masters copper patina paint, online through Amazon.

SELECTING THE RIGHT ADHESIVES

The glues that are most effective for these letter projects are hot glue, a quick-dry tacky white glue, and matte Mod Podge. I recommend using hot glue for projects in which you want to immediately adhere the craft materials, such as rope, stones, or pearls. The quick-dry tacky white glue works best for items that require more flexibility during placement, such as paper flowers, flat beads, buttons, and felt balls. This is because you'll want to be able to move the craft material around slightly as you work your way up the letter to follow its shape more

easily. When using a brush to apply glue, once finished, be sure to wash the brush thoroughly with soap before the glue can dry on it.

Finally, matte Mod Podge is perfect for any project in which you are adhering paper or fabric directly to the letter's surface. When using Mod Podge, be sure to allow the initial paper or fabric that you've adhered to dry thoroughly before applying a protective top coat, or else you are asking for bubbles and bumps to pop up in the surface of your project. I've also found the Mod Podge brush to be an amazing tool for applying my matte Mod Podge; the outcome is much smoother than any découpage results I've attained using a regular paintbrush.

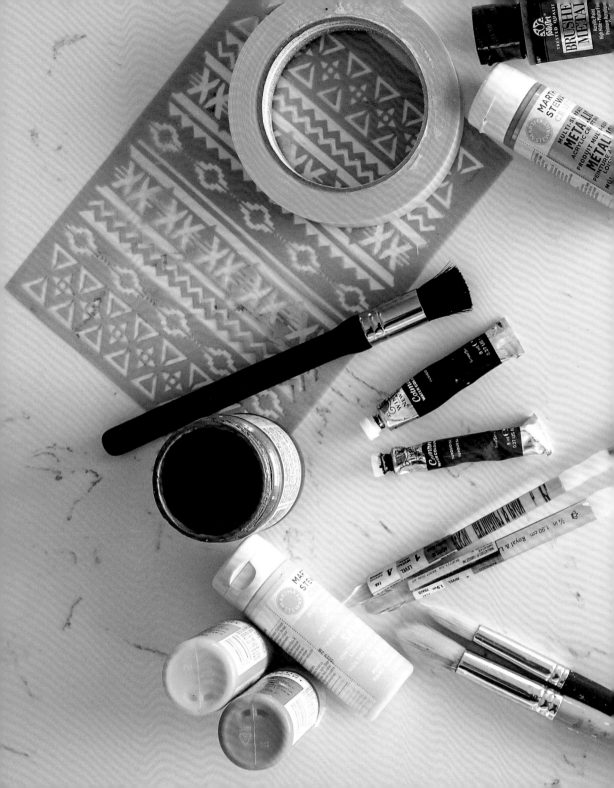

SPECIAL PAINT EFFECTS

01

crackle finish

This was probably one of the first crafting techniques I ever tried. Once I found out how much fun crackle medium was to use, there was a period of time when few objects escaped my crackle-paint obsession. Nothing adds an aged feel quite like layers of paint peeking through on the surface of an object. Very popular in the 1990s, these finishes are on the rise again as rustic, vintage, and farmhouse styles regain popularity. And they are equally beautiful whether you use contrasting colors (like the gray and teal of this letter) or similar colors that create subtle texture and layering.

MATERIALS

1 wood letter of your choice

2 (2-ounce) jars different-colored craft paint

1 medium craft paintbrush

1 (2-ounce) jar crackle medium

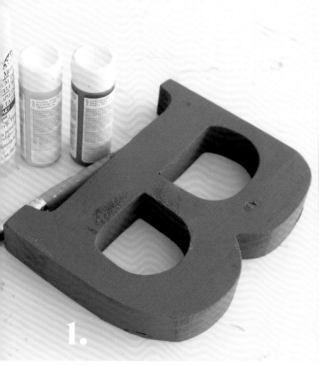

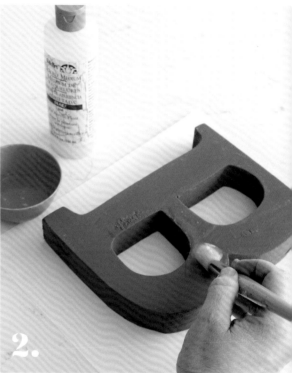

Start by giving the wood letter two coats of your base paint color, allowing dry time between and after each coat as recommended on the bottle. Paint the face, sides, and even the back of the letter if it will be visible.

Once the base coat is dry, paint on the crackle medium. The thicker application of the medium, the chunkier the cracks will be in your final paint coat.

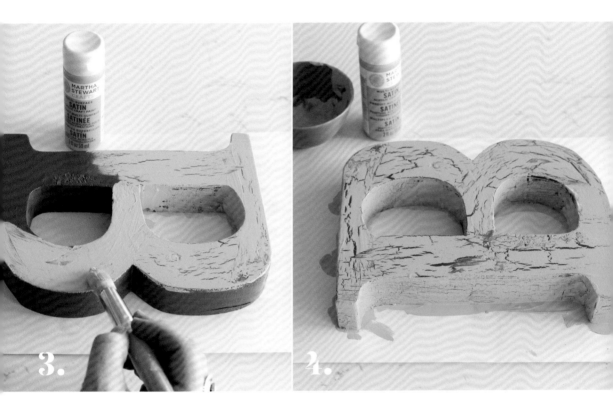

3.

4.

Before the crackle medium has dried, apply a layer of the top paint color. The thicker this paint layer, the chunkier the overall appearance of the crackling.

Let dry. As the crackle medium and final paint coat dry, the cracks will be revealed and the base coat color will show through.

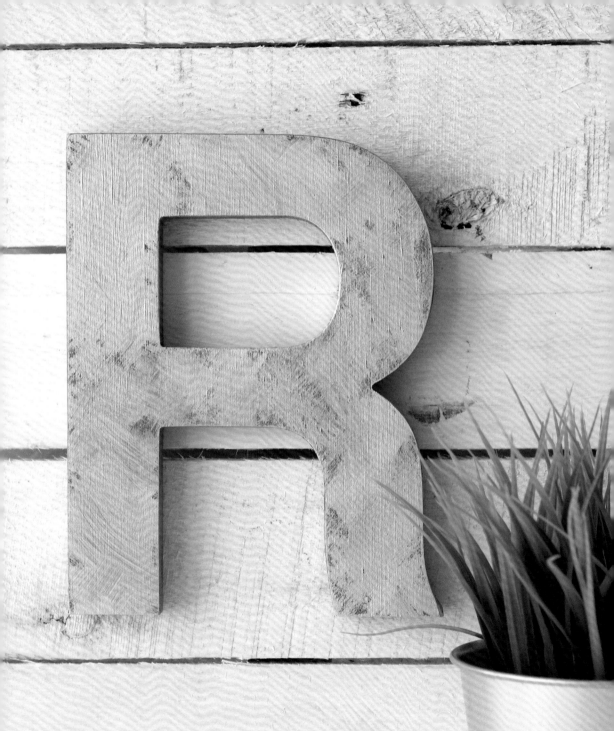

faux galvanized metal

Galvanized metal is created when a protective coating of zinc is applied to metal, such as iron or steel, as a way to prevent rusting. Often seen on farm and industrial tools, galvanized metal finishes are popping up everywhere in home décor, and they work perfectly with current industrial and farmhouse-style design trends. They also lend themselves well to the bedrooms of machinery-obsessed children!

To easily create this faux galvanized-metal finish, you use a dry-brush technique: you put just a bit of paint on the end of your brush, removing most of the paint from the brush by wiping it on the edge of a water bowl or a piece of paper or cloth, so that you're left with very little pigment there (hence the term *dry-brushing*).

MATERIALS

1 wood letter of your choice

1 (2-ounce) jar dark gray or black craft paint

1 medium craft paintbrush

1 craft paintbrush with dry and scraggly bristles

1 (2-ounce) jar matte metallic silver paint

1.

Apply two coats of the dark gray paint to your letter, letting each coat dry thoroughly after application.

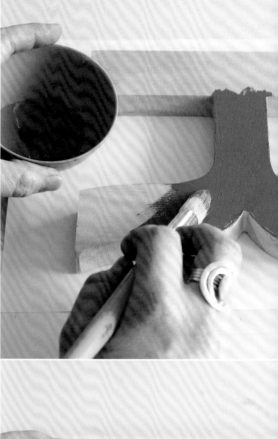

2.

Using the scraggly brush, apply the matte silver paint using a dry-brush technique.

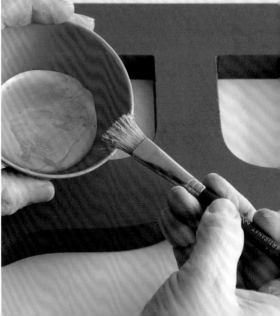

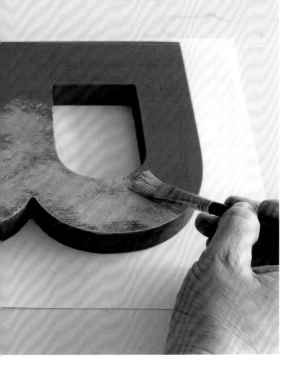

Move the dry-brush/silver paint in a cross-hatched fashion across the letter, creating texture and contrast over the dark gray color below.

NOTE: *Leave some bits of the dark base coat showing through to create the illusion of a textured finish with dimension.*

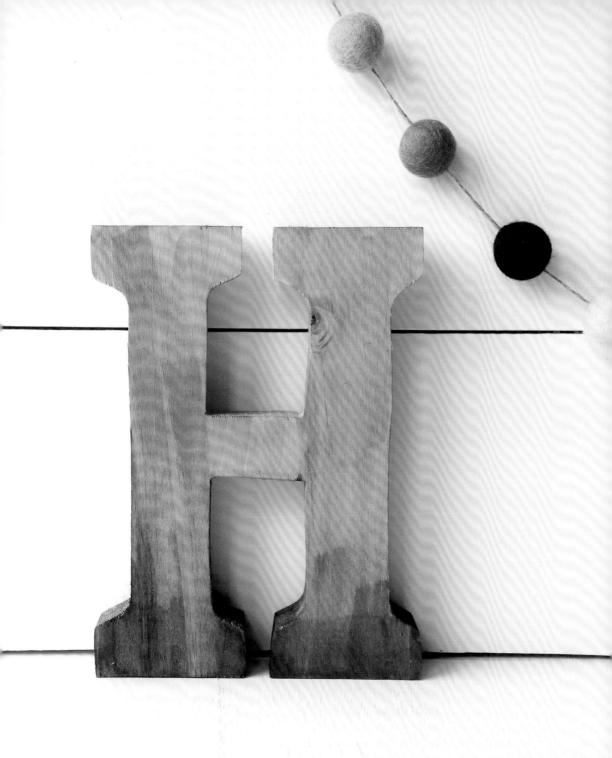

watercolor

Watercolor is an age-old medium that has been used for hundreds of years. The pigments in tube watercolor paint are suspended in a water-based solution. They are designed to be used wet, and they blend easily to create lovely shades and variations. Once considered very traditional and somewhat dated, watercolor has reemerged in the design world with a vengeance, as witnessed by the rise in popularity of splotches, blobs, and puddles of watercolors seen throughout graphic design, crafts, and décor. Even if you have never tried watercolor paints, you can easily create this simple ombré letter in a few quick steps.

MATERIALS

1 unprimed wood letter of your choice

2 small tubes of watercolor paint in tones that will create an ombré effect

1 watercolor brush

Plate or palette

Water

1. Put a dab of the lighter paint color on your plate, and mix it with some water. Saturate the watercolor brush with the paint.

2. Apply the color onto the letter starting at the top; covering the front, back, and sides; and working your way about one-third of the way down the letter.

3.

Dab some of the darker paint color onto your plate, and mix with water. Then begin painting the darker color on the bottom end of your letter, working your way about one-third of the way up the letter.

For the middle third of the letter, add some of the lighter color to your brush and work your way down slightly toward the darker color. Do the same with the darker color, eventually beginning to blend the two colors together in the middle of the letter.

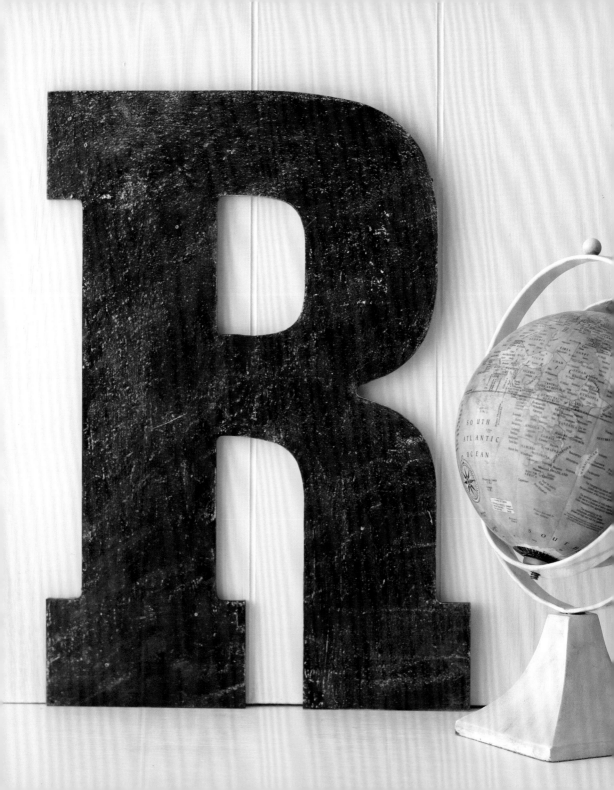

chalkboard

Perhaps because I'm a teacher and have such fond memories of school in general, I find projects made with a chalkboard finish so appealing. It's a very traditional look but can be used to create a modern, fun, and trendy letter project. In existence as teaching tools for hundreds of years, chalkboards have exploded in popularity recently—so much so that chalkboard paints are available in a variety of colors in most craft, big-box, and hardware stores, and are used to paint everything from clay pots to mason jars to entire tables and walls. A flat, block-design letter works well for this project. Perfect in a child's room, playroom, office nook, or even kitchen, a chalkboard letter is both cute and functional, as you can use it to write quick notes, reminders, or inspiring quotes. You could even spell out words like *eat* or *menu* in your kitchen, or words like *read*, *learn*, or *play* in a child's space.

MATERIALS

1 wood letter of your choice

1 (2-ounce) jar chalkboard paint (in the color of your choice)

1 medium craft paintbrush

Chalk

Dry cloth or rag

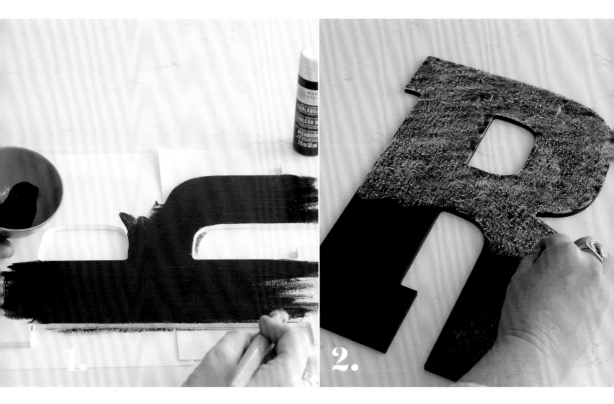

1. Apply two coats of chalkboard paint to the wood letter, letting each coat dry thoroughly following the instructions on the paint jar for dry times. If the back of the finished letter will be visible, you should paint it as well. Allow the chalkboard paint to cure for 24 hours before using it.

2. To seal your chalkboard paint so that the first words you write on it will not be permanently etched into the surface, "prime" the cured chalkboard by rubbing it all over with chalk.

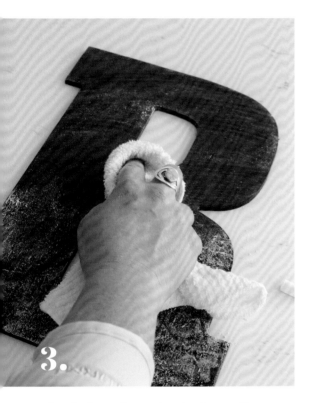

3.

Wipe the letter clean using the dry rag. The chalk will leave a slightly hazy finish.

NOTE: *Once the letter is primed, it is ready to use. You can write quotes, verses, or notes on it, or draw little pictures to decorate it. You could use it as a memo board, or create a more permanent design on it using a chalkboard pen (available at craft stores).*

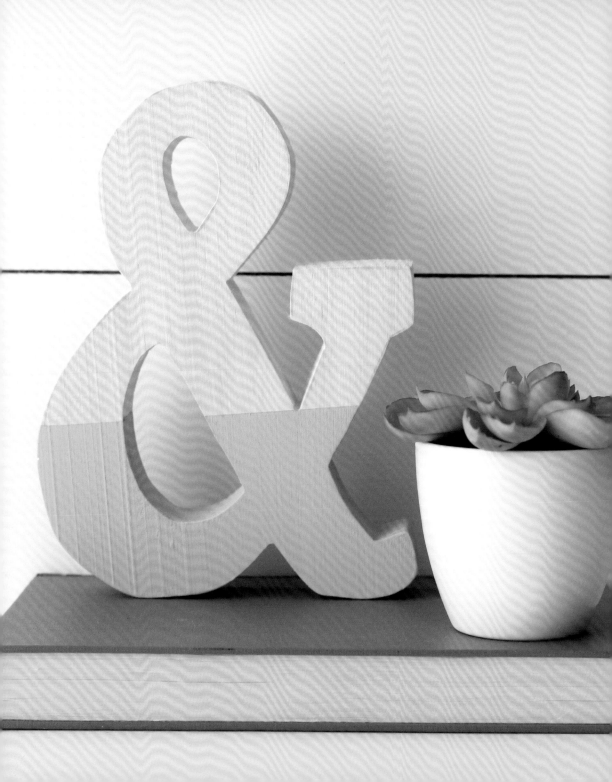

color blocking

Color blocking, often seen on fabrics and fashion designs, is when an item is composed of finite blocks of color. The selection of contrasting colors lends further pop to items treated with this fun technique. Originally popular in fashion and décor in the 1960s, color-blocking creates a fun, modern feel, and color-block letters are no exception. Given a slightly more rustic touch with the use of contrasting stain and paint, this ampersand would be a perfect accent on a bookcase or displayed on a gallery wall.

Note that it's important to use delicate-surface painter's tape, which is designed for use on surfaces that have been very recently painted (or stained). Also note that instead of pickling stain, you could use another paint color, one that contrasts with your first paint color choice.

MATERIALS

1 unprimed wood letter of your choice

1 piece 150 (or higher) grit sandpaper

Dry, lint-free cloth

1 (2-ounce) jar craft or pickling stain

1 or 2 medium craft paintbrushes

1 roll delicate-surface painter's tape

1 (2-ounce) jar craft paint

1.

Give your wood letter a light sanding before painting if it isn't totally smooth, and wipe off any sanding dust with a lint-free cloth.

2.

Give the top third of the letter a coat of stain. Once the stain has dried for a short time, wipe off the excess with a dry, lint-free cloth, and then allow the remaining stain to dry fully.

Tape a line across the stained top of the letter using delicate-surface painter's tape. Be sure to press down the edge of the tape firmly enough so that the craft paint will not leak under it.

Apply two coats of craft paint to the bottom two-thirds of the ampersand, letting each coat dry fully after application. Once dry, carefully remove the tape to reveal a crisp line between the two blocks of color.

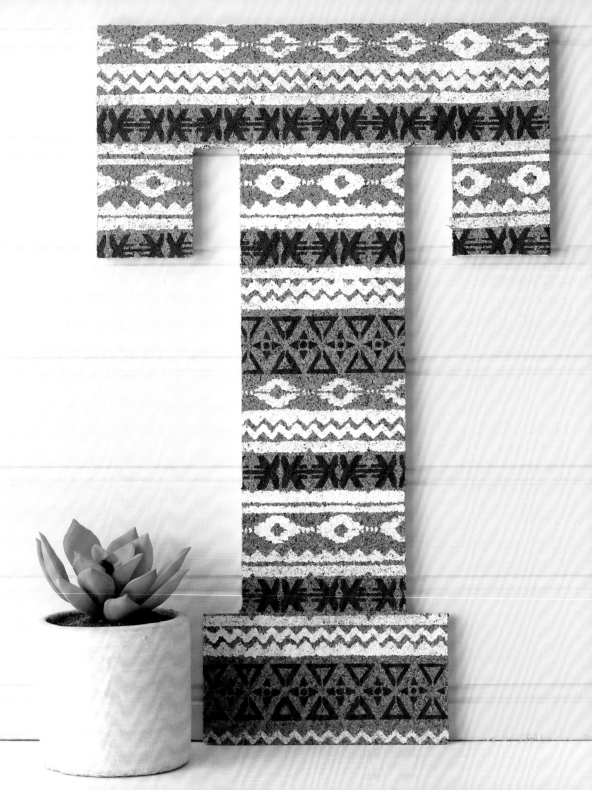

cork and stenciling

Stenciling is a great paint technique that allows you to easily add interest and pattern in almost any style imaginable. With the huge variety of stencils available at craft stores, I thought this slightly boho stencil would look perfect layered over the rustic texture of the natural cork. It would be very easy to cover a letter with cork and stop there, perhaps using it as a decorative corkboard, but I thought I'd take this project a step further. A series of cork-covered letters spelling words like *family*, *work*, or *life* could be used to create a unique and informal display.

MATERIALS

1 wood letter of your choice

Scissors

1 package cork roll

1 small container craft glue

X-Acto knife

Cutting mat

1 roll delicate-surface painter's tape

Stencil

1 or 2 (2-ounce) jars craft paint (in colors of your choice)

1 small to medium stencil brush

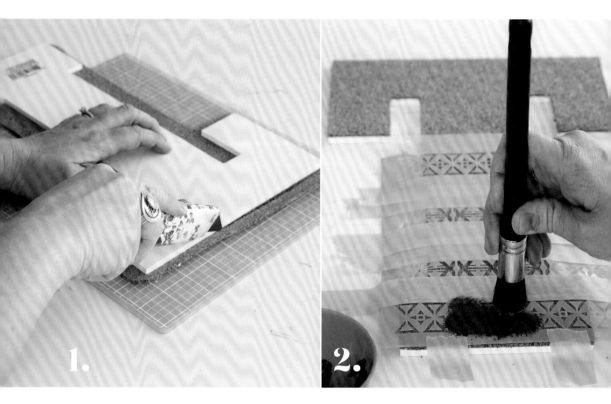

1. Cut a piece of cork slightly larger than your letter. Adhere the cork to the letter using craft glue, pressing on it until it stays in place. After the glue has dried and the cork is well adhered to the letter, use an X-Acto knife and a cutting mat to carefully trim the cork to the shape of the letter.

2. Use painter's tape to hold the stencil in place on the letter while doing your stenciling. When stenciling, be sure to dab directly up and down; do not paint using a traditional brushing motion or you risk the paint bleeding under the stencil.

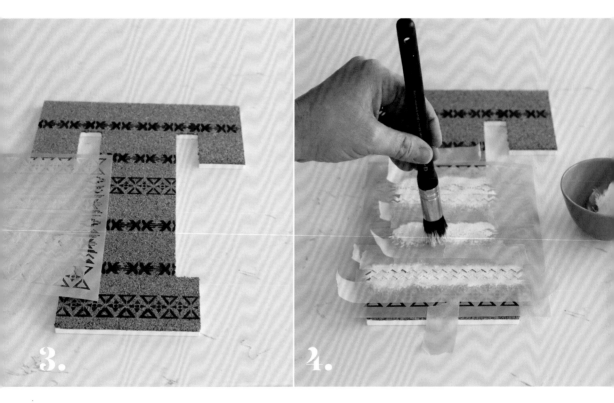

3. Remove the stencil, wash and dry it, and leave the letter untouched until the first layer of paint is dry to the touch before placing the stencil again. To complete your first layer, move the stencil up the letter, making sure to overlap and line up the design correctly.

4. After completing all the stenciling with one color and allowing it to dry to the touch, overlay the stencil again, lining it up with the pieces you've painted. Tape over the painted pieces and proceed with stenciling the second color. Wash, dry, and move the stencil up as you did in step 3 to complete the second layer of color.

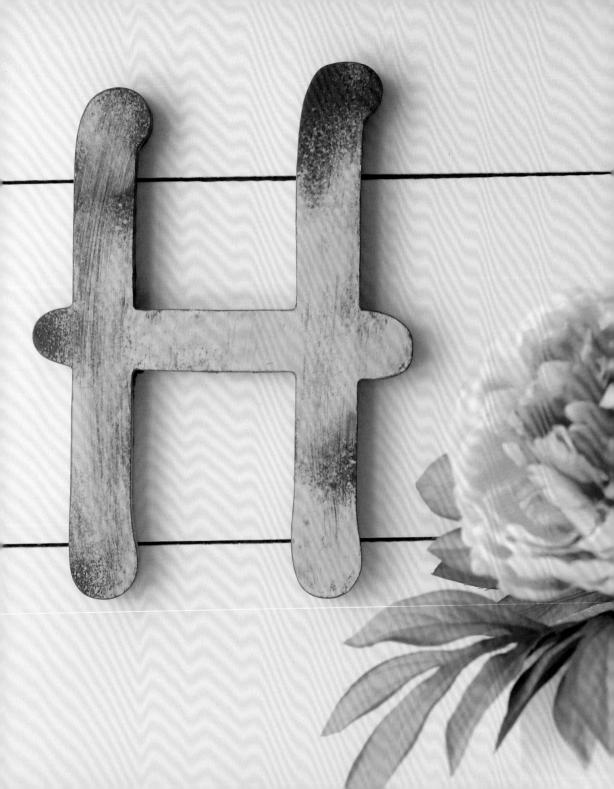

copper patina

There is something so timeless and beautiful about the rich color of copper peeking through layers of "aged" blue-green patina. One of the first metals to be utilized by humans due to that fact that it is directly usable in its natural form, copper and the verdigris patina that occurs over time as it oxidizes create a beautiful old-world feel. Letters decorated in this finish would be beautiful on their own for a family monogram, or combined to spell a name or words like *live, love,* or *XOXO.*

The special paint I used for this project is available through Amazon, or you can check the brand website, www.modernmasters.com, for retailers near you.

MATERIALS

1 wood letter of your choice

1 small bottle Modern Masters Metallic Primer

2 medium craft paintbrushes

1 small jar Modern Masters Copper Paint

1 small bottle Modern Masters Green Patina Aging Solution

1.

Start by painting the letter with the Modern Masters Metallic Primer. Let it dry overnight (24 hours is recommended for curing). If the finished letter will be visible from the back, paint all sides.

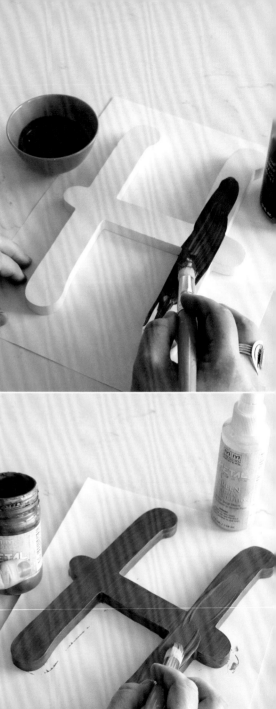

2.

Paint the letter with two coats of the copper paint. Let it dry for 30 minutes between coats.

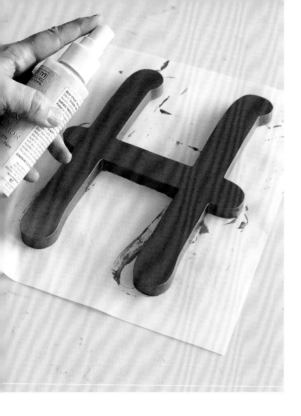

After you've applied the second coat of copper paint, immediately spritz on the green patina aging solution wherever you'd like the patina effect to appear. The more solution you apply, the heavier the patina finish will be. I spritzed fairly heavily but left some areas quite bare near the top.

NOTE: *As the paint and solution dry, the patina will begin to show through. It will continue to develop until fully dry.*

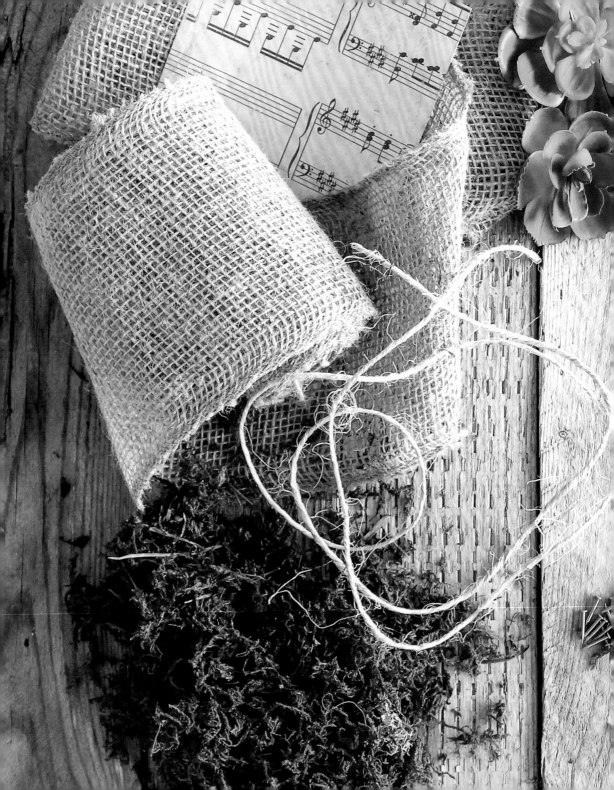

RUSTIC AND FARMHOUSE

02

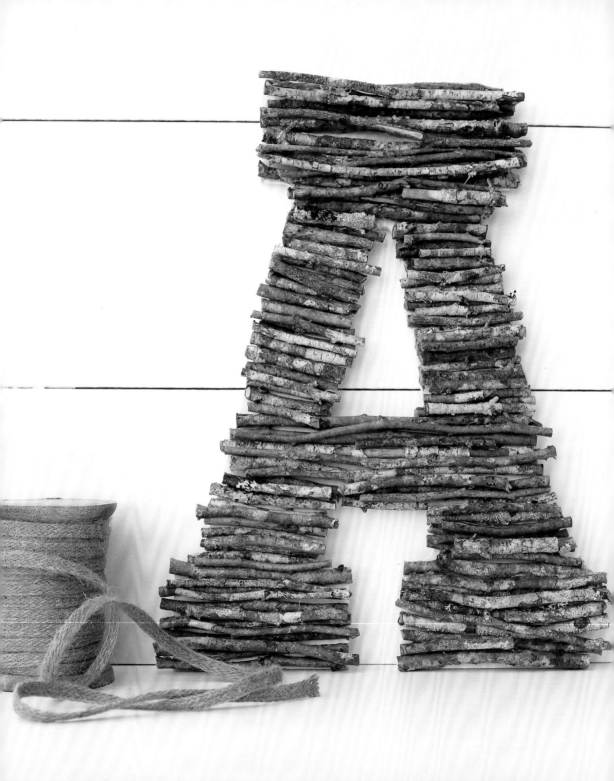

twigs

Every time we go walking in the woods, my boys come home with little collections. Some days it's rocks, other days it's pinecones, and the time I was inspired to craft this letter their collection was twigs. One of the simplest, rustic crafting tools that you can use, twigs are free, easy to find, and beautifully varied in their natural textures. It is difficult to match the rural elegance of crafts made from twigs. Equally at home in a fall or winter vignette, a child's bedroom, a family gallery wall, or as country wedding décor, twig letters have a diverse appeal. They would also work beautifully on a wreath for the front door or used to spell out words such as *fall, grow,* or *family tree.*

MATERIALS

1 wood letter of your choice

1 (2-ounce) bottle white or neutral-colored craft paint

1 medium craft paintbrush

Twigs

Sharp outdoor garden clippers

Hot-glue gun and glue

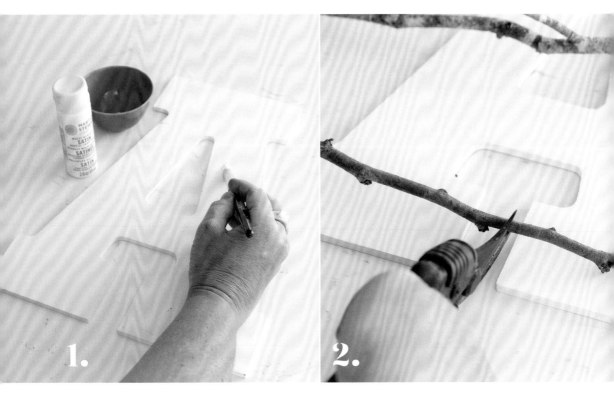

1.

2.

Apply a base coat of white craft paint to your wood letter. (If you opt for a neutral color, try picking a tone that matches the shades of your twigs.)

Cut the twigs to size using sharp garden clippers.

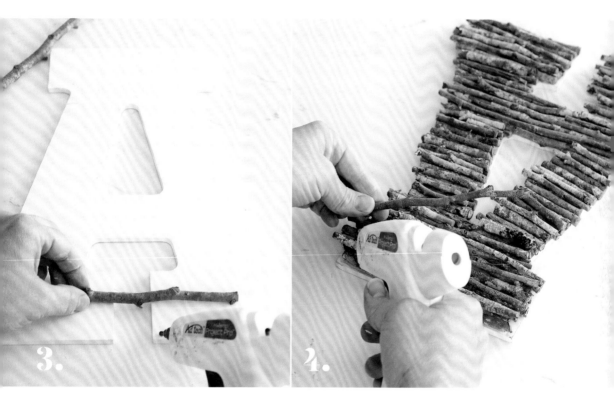

3.

Use hot glue to attach the twigs to the wood letter, starting at the bottom and working your way up the letter.

4.

Cover the whole surface of the letter first, and then add another layer of twigs on top to cover and disguise any gaps.

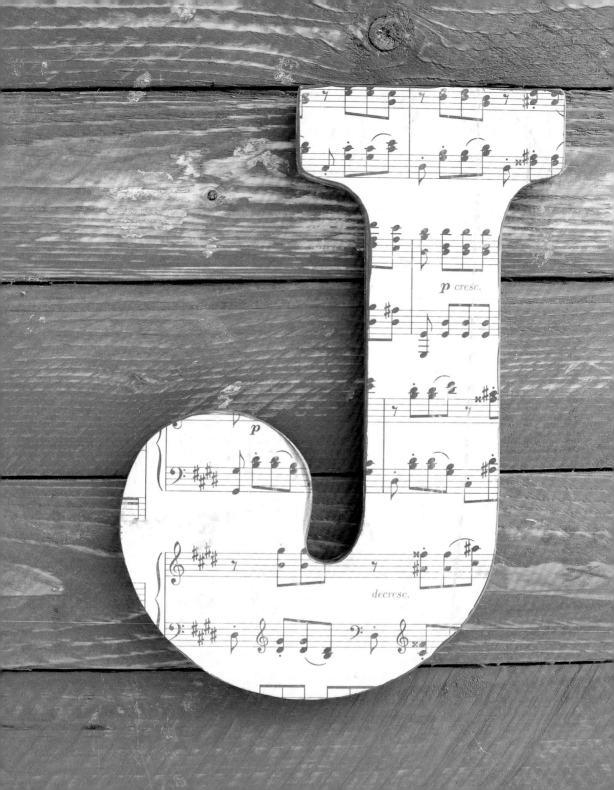

sheet music

"Whenever humans come together for any reason, music is there . . . it is therefore a window on the essence of human nature." —Daniel Levitin, *This Is Your Brain on Music*, 2006

Music is most certainly one of the most appreciated and loved art forms; but more than that, it is a method of communication the depth of which is hard to match. A letter decorated with sheet music can be more general in intent—i.e., a nod to the importance of music in one's life, or it can be made more significant or personal by using sheet music of a specific composition that is important to you or to the one for whom you are creating the letter. The antique feel of a vintage piece of sheet music lends itself beautifully to many popular current home décor looks, including the all-popular farmhouse style. Sheet-music scrapbook papers can be purchased at craft stores or downloaded online and printed. This project would also look beautiful created with vintage book pages.

MATERIALS

1 wood letter of your choice

2 (2-ounce) jars craft paint: one tan and one dark brown or gray

1 medium craft paintbrush

Vintage sheet music or sheet-music scrapbook paper

Pencil

Scissors

1 (2-ounce) jar matte Mod Podge

1 Mod Podge brush

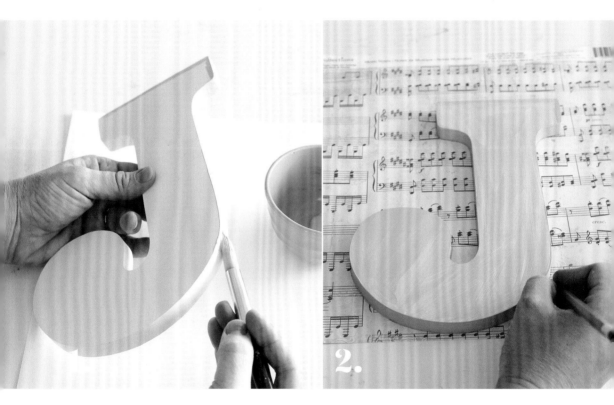

Coat the edges of your letter with the tan craft paint, and let dry.

Place the letter on top of the sheet music (right side of paper facing up). Trace the shape of the letter onto the sheet music, and cut it out.

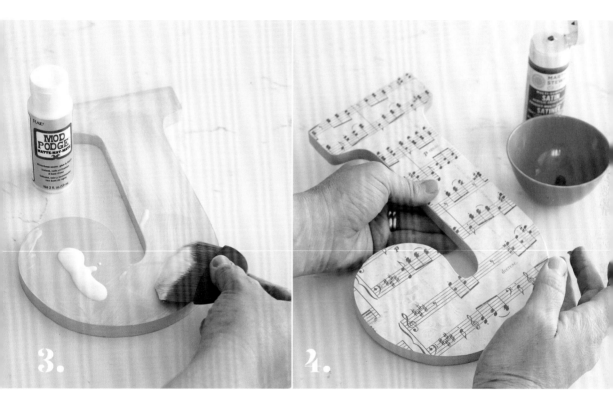

3. Apply Mod Podge to the surface of the letter using the Mod Podge brush. Gently place the paper on the letter, making sure to carefully line up the edges.

4. Add texture, depth, and an aged feel to the letter by applying a few coats of matte Mod Podge in a thick, cross-hatched motion, letting it dry between coats. Create an aged, rustic edge by applying the dark brown paint roughly over the tan base coat, and let that dry.

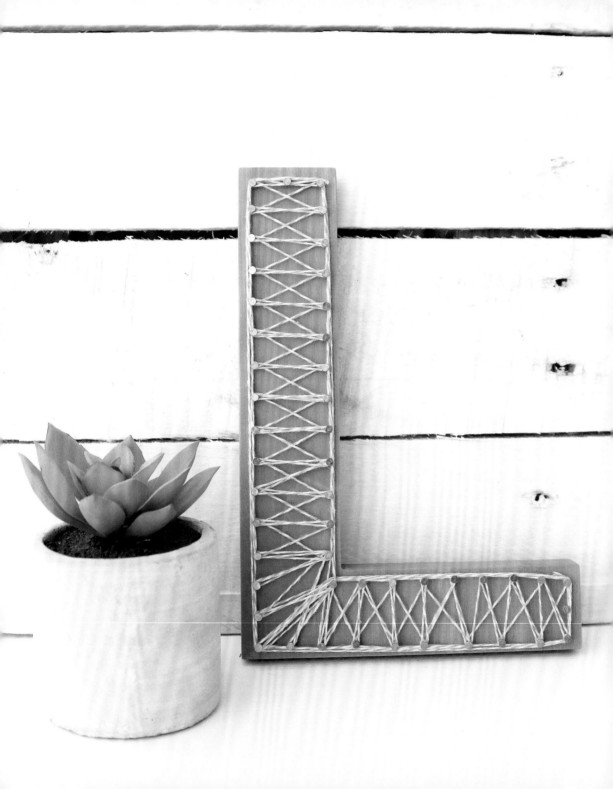

string art

Originally invented in the early 1800s as a mathematical tool for teaching children, string art evolved in the 1960s into a fun and simple craft using pins and thread. Recently reemerging as a hot new craft and décor trend, string art has an interesting graphic and textural quality that makes it versatile and appealing. You can vary the overall look of any string-art design by changing the letter color or the string style and color, or by increasing the complexity of the string wrapping by changing the number of nails used. Note that a thicker style of wood letter works best for the nailing required in this project, and while you can use any combination of craft paint or stain and string, I used gray pickling stain and blue-and-white baker's twine here.

MATERIALS

1 wood letter of your choice

1 (2-ounce) jar craft paint or stain

1 medium paintbrush

12-inch ruler

Sharp pencil

Dry, lint-free cloth (if using stain)

Hammer

1 small package ½-inch 17-gauge cigar box nails

String or thin twine

1.

Coat the front, sides, and back of the letter with your chosen paint, and let dry thoroughly. If using stain, once the stain has dried for a short time, wipe off the excess with a dry, lint-free cloth.

2.

Measure and mark spots for the nails, spacing them evenly around the edges of the letter. Hammer each nail carefully into the pre-marked spots, taking care to make them as level with one another as possible.

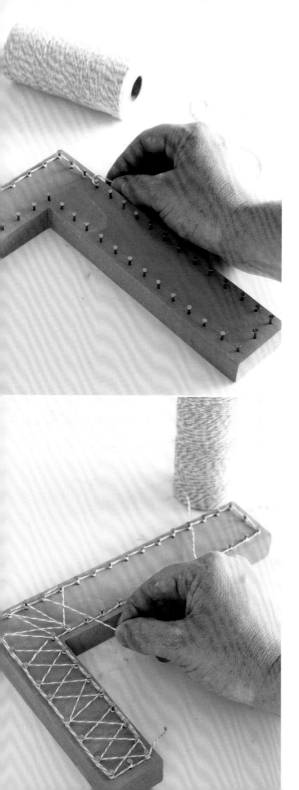

3.

Tie the string around one corner nail, and twist the string around the whole outside edge of nails.

4.

Then begin twisting the string in an angled or crisscross formation, wrapping it around the nail heads and moving along the entire letter. Finish by wrapping the string once more around the exterior edge of all the nails, tying it off when done.

NOTE: *There is no right or wrong way to wrap the string; the key is to create an effect that is pleasing to you.*

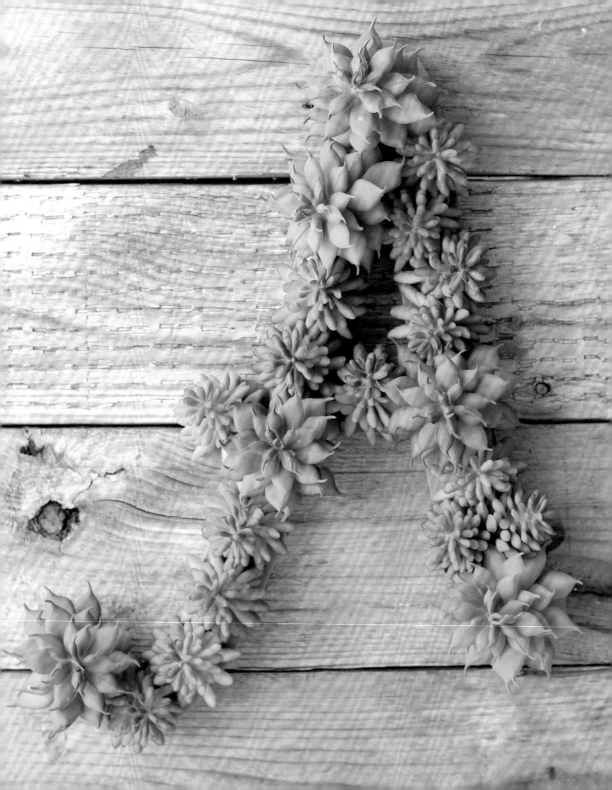

faux succulents

Succulents are such strong and resourceful plants. By their very nature and design, they are able to withstand and flourish in the most difficult of growing conditions. While flowers are stunning with their lovely show of color, succulents have a quiet beauty that is difficult to surpass and that works perfectly with so many décor styles. With succulents being all the rage right now, this letter covered with faux succulents is one of my favorites in the book. I think it would be equally at home displayed on a wall, a bookshelf, or your front door. You can find faux succulents at any number of craft, home-and-garden, and big-box stores.

MATERIALS

1 wood letter of your choice

1 (2-ounce) jar moss-green craft paint

1 medium craft paintbrush

Selection of faux succulents

Small wire cutters or sharp scissors

Hot-glue gun and glue

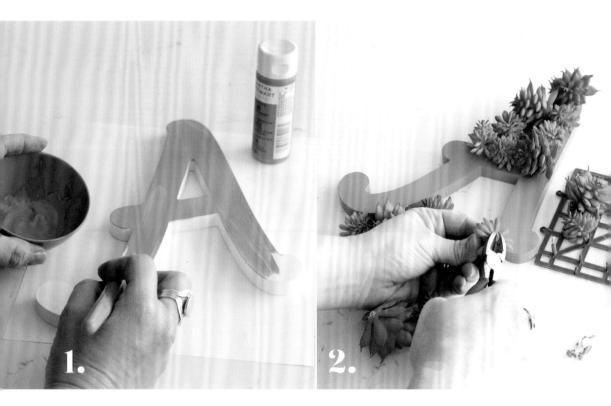

1. Give the wood letter one or two coats of the green craft paint so that it will be green underneath the succulents, in case any small spots show through between them. Paint the front and sides, as well as the back of the letter if it will be visible on your finished letter project.

2. If using a sheet of faux succulents, use wire cutters to remove the succulents from the sheet, and cut the plastic nibs down as close as you can to the bottom surface of each succulent to create a flat base.

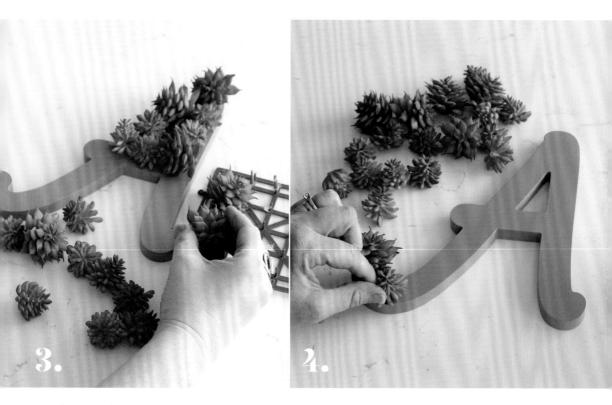

3.

Practice arranging the succulents on the letter until you come up with a design you like.

4.

Use a hot-glue gun to attach the succulents to the face of the letter, holding them in place briefly as the glue sets.

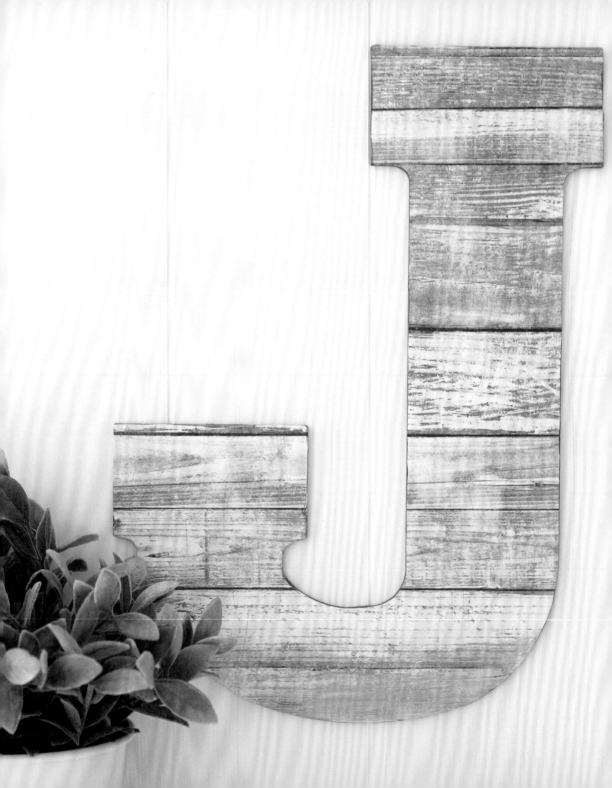

faux wood planks

Rustic wood planks are huge in home décor and crafts these days. Everywhere you look, someone is making something out of pallet wood or old planks: walls, beds, furniture, crates, and small décor items like this wood letter. But if you don't want to use power tools or are looking for a less sliver-causing version of planks for a project, then the high-resolution images available for scrapbooking in craft stores or online (through shops like Etsy) are perfect! This simple faux plank letter would be fabulous in a bedroom or on a family gallery wall, and it took a lot less time and effort to make than an authentic plank letter would.

MATERIALS

1 wood letter of your choice

2 (2-ounce) jars craft paint: one tan and one dark brown or gray

1 medium craft paintbrush

Faux wood plank paper

Pencil

Scissors

1 (2-ounce) jar matte Mod Podge

1 Mod Podge brush

1.

If you want to paint the back or edges of the letter, then do so first with the tan paint. Next, lay the letter on top of the faux-wood paper, with the paper right-side up. Trace the shape of the letter onto the paper, and cut it out. If the paper is not large enough to fit the entire letter, you can fill in by cutting pieces to join up seamlessly.

2.

Apply Mod Podge to the surface of the letter using the Mod Podge brush. Gently place the paper onto the letter, making sure to carefully line up the edges. Continue with any additional pieces of paper.

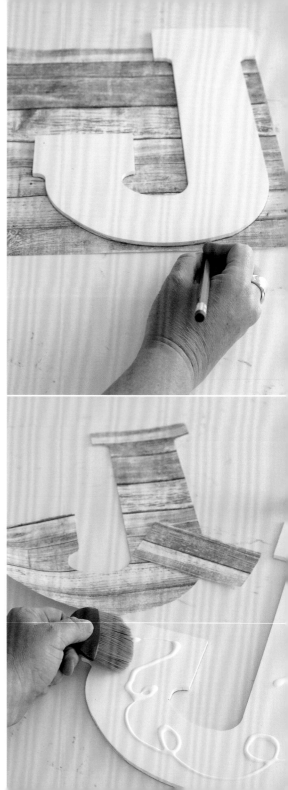

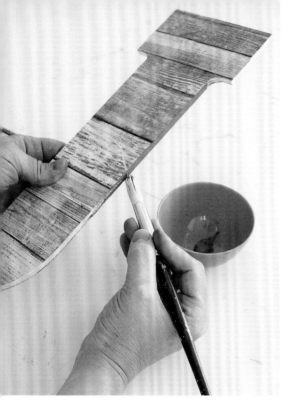

Create a rustic letter edge by applying dark brown or gray paint along the edges, roughly, over the tan base coat.

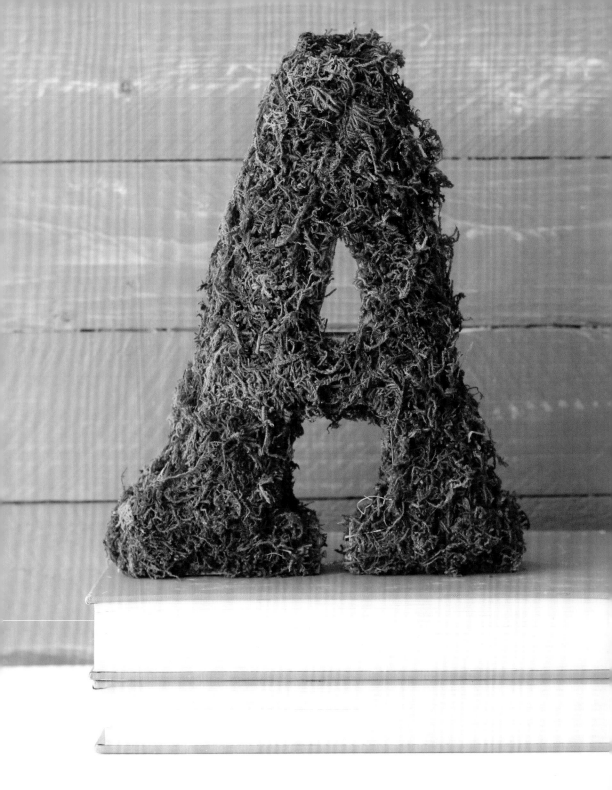

sheet moss

"Moss is *nature's carpet*." —Anonymous

When a good friend recently asked me to help
her design her wedding décor, I immediately
thought of moss. Something about the deep
green color and the texture of moss evokes
the feeling of lush, dense, verdant forests that
smell of earth and new life. Moss has a rustic
elegance that makes it perfect for creating
monogram letters to be used on a head table
at a wedding. When used in home décor
accents, moss adds a rich, natural feel that
works beautifully with styles ranging from
farmhouse to cottage, boho to chic. This
moss-covered letter would also be equally at
home on a bookshelf or attached to a wreath
for the front door.

MATERIALS

1 wood letter of your choice

1 (2-ounce) jar moss-green craft paint

2 medium craft paintbrushes

1 small jar craft glue

1 bag sheet moss

Scissors

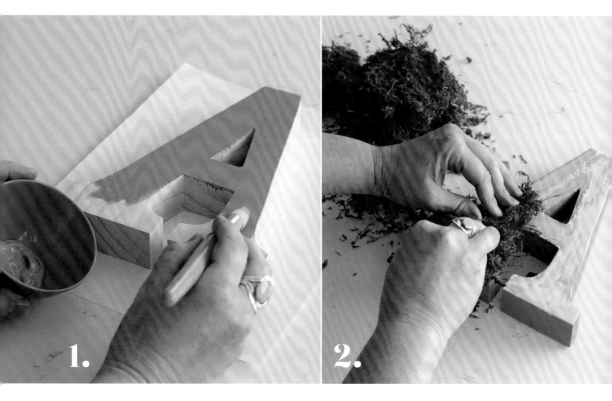

1.

Apply one coat of the moss-green craft paint to your letter, and let dry thoroughly before proceeding.

2.

Using another brush, cover one section of the letter with craft glue. Tear off enough sheet moss to attach to that section before the glue has time to dry. Press the moss down, and hold it in place until it sets. Add craft glue to the next section, and cover that area with more moss.

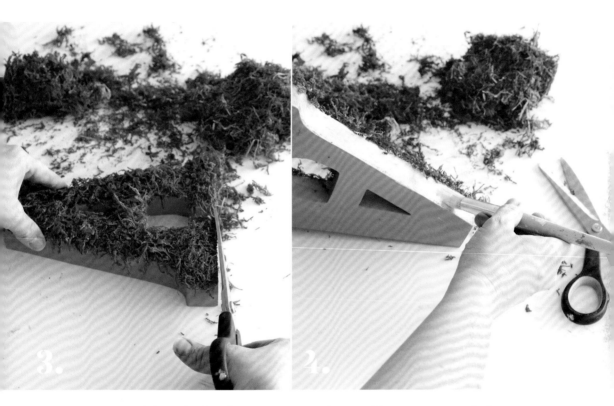

As you go, you may wish to trim the edges in a few places to create a crisp, clean edge to the moss.

Continue working your way over the letter, including the sides, until you've covered the whole letter with moss. Let the glue dry, and trim the remaining edges as needed.

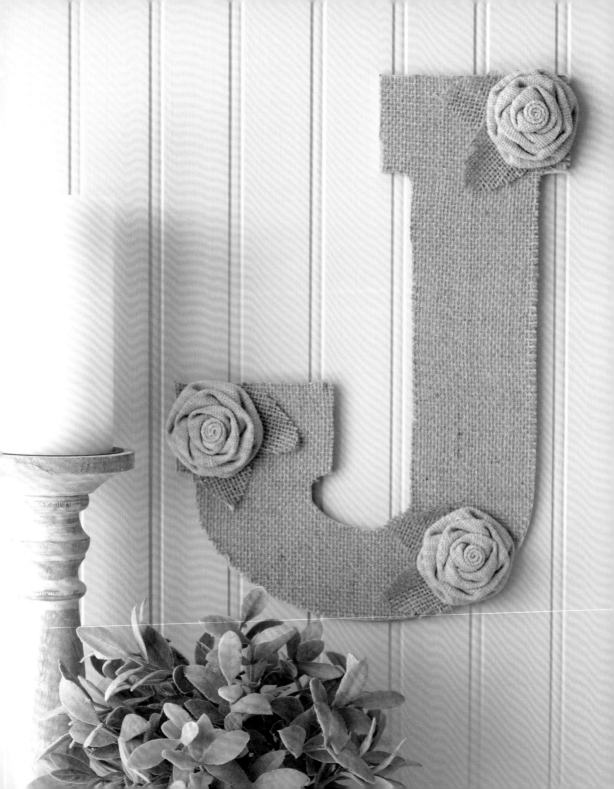

burlap

Few things create a rustic, farmhouse feel quite like plain, old-fashioned burlap. A tough and serviceable fabric woven from jute or sisal fibers, burlap has a natural breathability that lends itself well to its frequent use in shipping and food transport and storage. Often seen on wreaths, interior decoration accents, and even pillows or drapery, burlap is a fun way to add some natural texture to your décor. Additional decorative flowers can be found at craft stores or fashioned out of any extra burlap you may have.

MATERIALS

1 wood letter of your choice

Felt pen

Burlap fabric, enough to cover the face of your letter

Fabric scissors

1 (2-ounce) jar tan craft paint

1 medium craft paintbrush

1 (2-ounce) jar matte Mod Podge

1 Mod Podge brush

Decorative burlap flowers (optional)

Craft glue

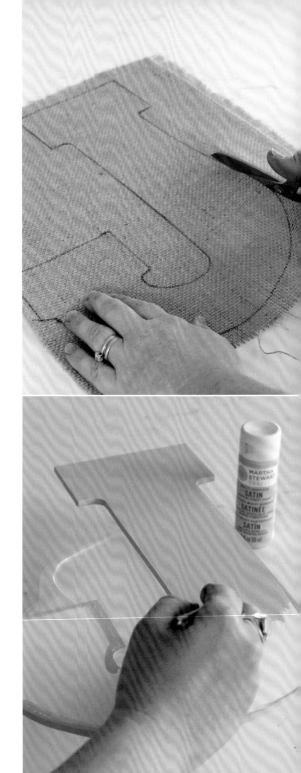

1.

Using the felt pen, trace the shape of your letter onto the burlap, and then cut it out carefully using fabric scissors.

2.

Paint the sides and front of the letter with the tan craft paint. Let dry.

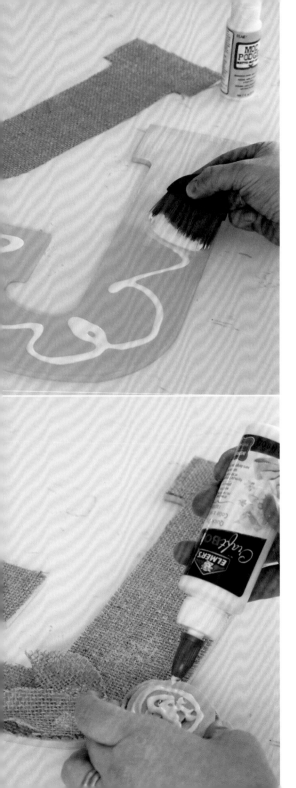

3.

Spread the matte Mod Podge onto the surface
of the letter using a Mod Podge brush, and then
press the burlap cutout to the letter gently until
it stays in place. Let dry.

4.

Add decorative details to the letter, such as
small burlap flowers and leaves, with craft glue.

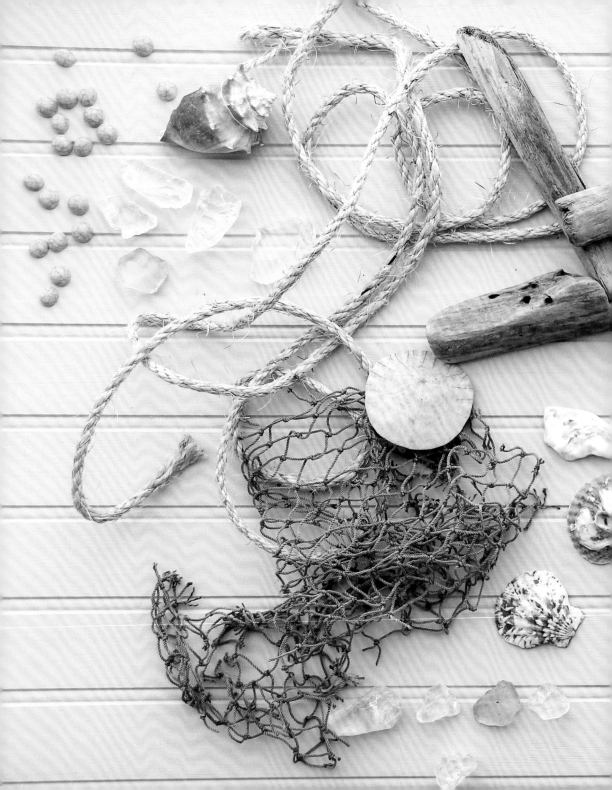

COASTAL AND BEACHY

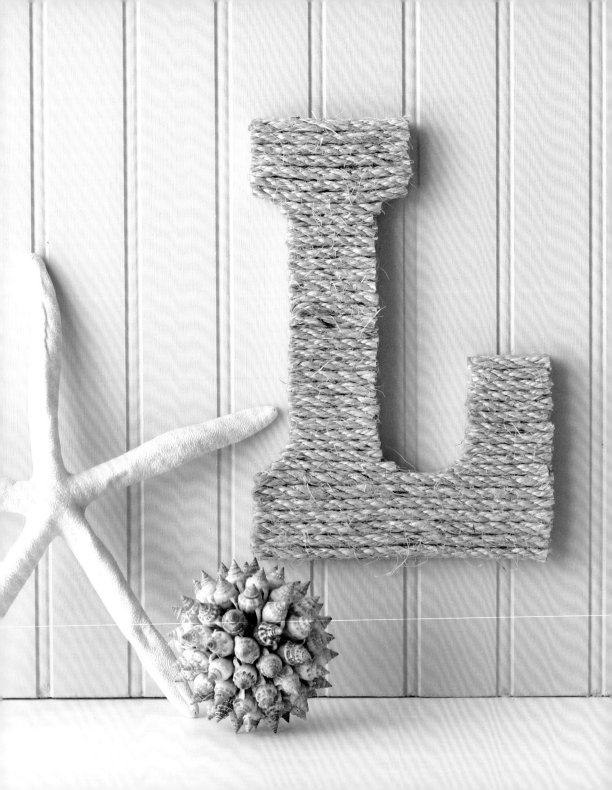

rope

Made of plies or strands of fibers twisted together to create a stronger form, rope is symbolic of strength and service. Long a symbol of sailing and the sea, rope is a fitting accent for coastal home-décor styles. It adds beautiful texture to any piece you create with it, and this lovely rope-covered letter is an easy way to bring a rustic beach feel to any space in your house. A large version of this letter would look amazing above a headboard in a nautical-themed bedroom. A block-style letter may be easiest to work with for this project.

MATERIALS

1 wood letter of your choice

1 (2-ounce) jar tan craft paint

1 medium craft paintbrush

1 small roll sisal rope (medium thickness)

Sharp scissors

Hot-glue gun and glue

1.

Apply one or two coats of paint to the edges of your letter, and let dry thoroughly.

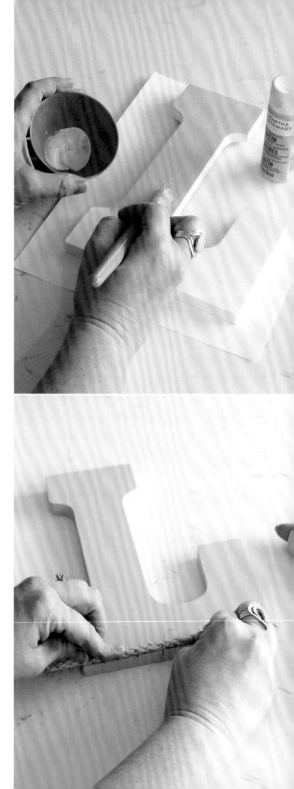

2.

Using the letter itself as a guide, measure the rope, and cut several strands as close to the width of your letter as possible. Use a bead of hot glue to attach strands one at a time to the front surface of the letter. Hold each strand in place briefly while the hot glue sets.

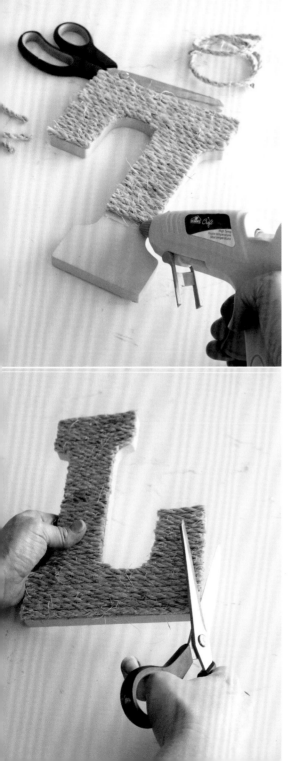

Work your way up the letter, cutting pieces of the rope and gluing them to the letter until the front has been covered completely.

4.

Use sharp scissors to even out the edges after all of the rope has been glued on and the glue is dry. The rope will naturally fray slightly on the ends but should stay relatively tight together, as long as you aren't touching and playing with it.

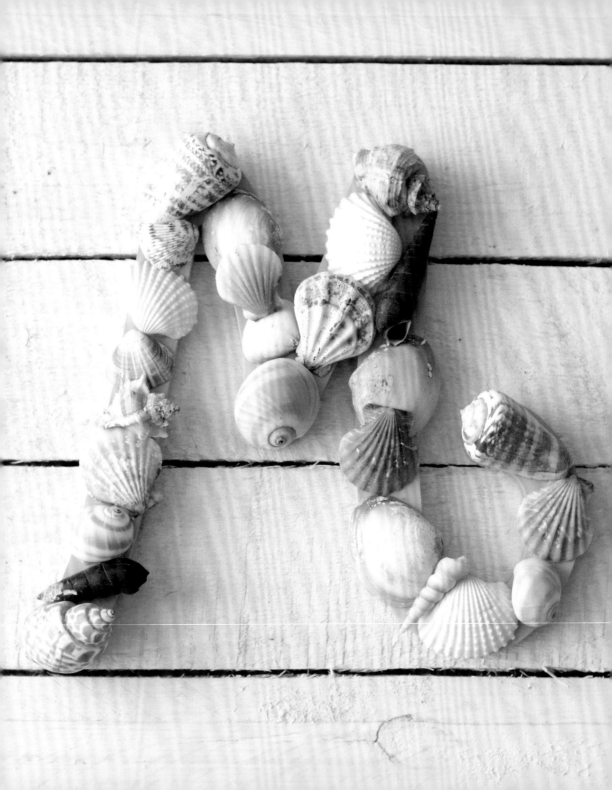

shells

You know all of those shells that you and your family collect on visits to the beach? What better way to remember your trips and display your shells at the same time than by using them to decorate a wood letter? You can also buy packages of shells at craft or dollar stores if you don't have a personal collection. This shell-covered letter would be a lovely addition to a coastal-themed room or in a summer-themed mantel display or vignette. Shells have such pretty natural tones and textures that they are stars on their own, and when arranged on a pretty, handwritten-style letter, they truly shine. Shell letters would look beautiful spelling out *beach* or other ocean-related words such as *breathe, sea,* or *calm.*

MATERIALS

1 wood letter of your choice

1 (2-ounce) jar tan or shell-colored craft paint

1 medium craft paintbrush

Shells

Hot-glue gun and glue

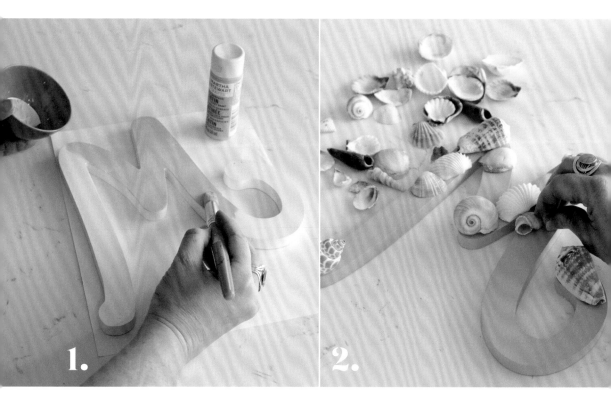

1.

Apply one or two coats of tan craft paint to the front, sides, and back of your letter, and let it dry thoroughly.

2.

Practice arranging the shells on the letter surface until you come up with a design that you like.

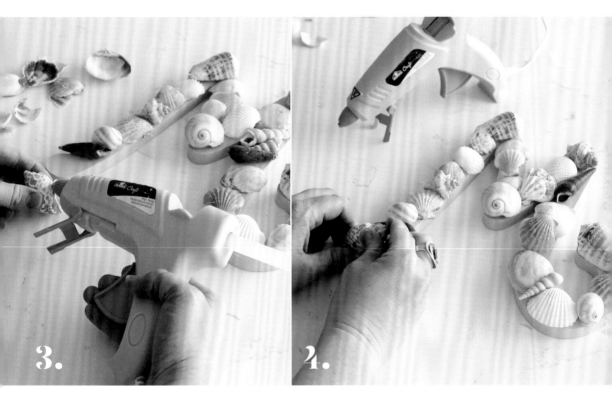

3.

Put a dab of glue on the flattest base part of a shell and hold it in place on the letter until it sets.

4.

Continue to work your way along the letter until all of the shells have been glued into place.

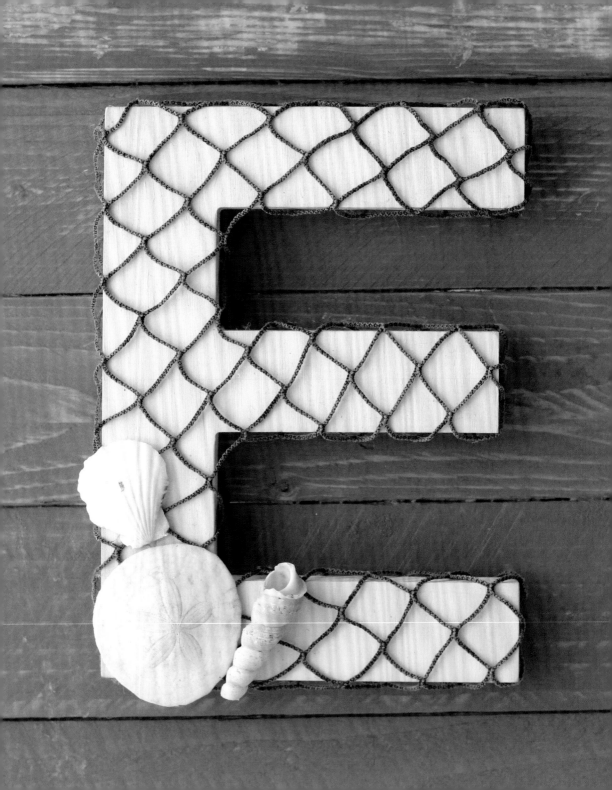

fishing net

"May the holes in your net be no larger than the fish in it." —Irish proverb

Fishing is a huge part of the culture where I live, and while most fishermen in our area now troll for their catch, there are still those who use nets. Dating back to almost the beginning of time, fishing nets hark back to a simpler way of life in which people regularly caught and harvested their own food. Covering a stained wood letter with a fishing net adds interest and texture while being fairly neutral in color, and it definitely adds a coastal flavor to your décor. While I opted for white pickling stain, you could choose a wood-toned stain or different color of picking stain to vary the final look.

MATERIALS

1 wood letter of your choice

1 (2-ounce) jar white pickling stain

1 medium craft paintbrush

Dry, lint-free cloth

Fishing net

Hot-glue gun and glue

Sharp scissors

Decorative add-ons, such as sand dollars and shells (optional)

1.

Cover the front, back, and sides of the wood letter with the white pickling stain following the instructions on the jar. Let the stain dry briefly, and then wipe the excess off with the dry cloth.

2.

Allow the stain to dry fully. Then lay the letter over the fishing net, back side up. Begin by attaching the net with hot glue to the back of the letter at the top. Pull and stretch the net until it is tight, and then cut the net so that you can wrap it as needed around the various arms of the letter.

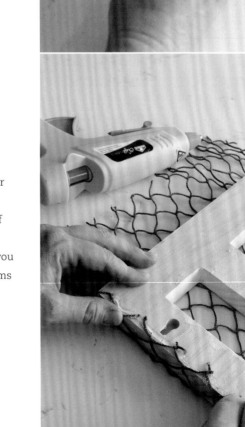

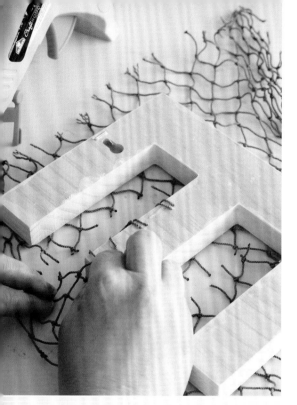

3.

Work your way from the top of the letter to the bottom, gluing each section in place before you cut the next section of net to fit.

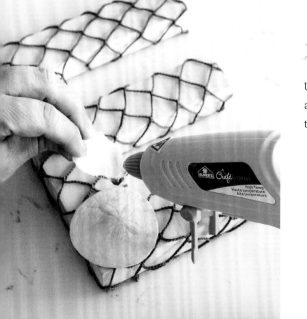

4.

Use hot glue to add optional decorative additions, such as shells or sand dollars, to embellish the design.

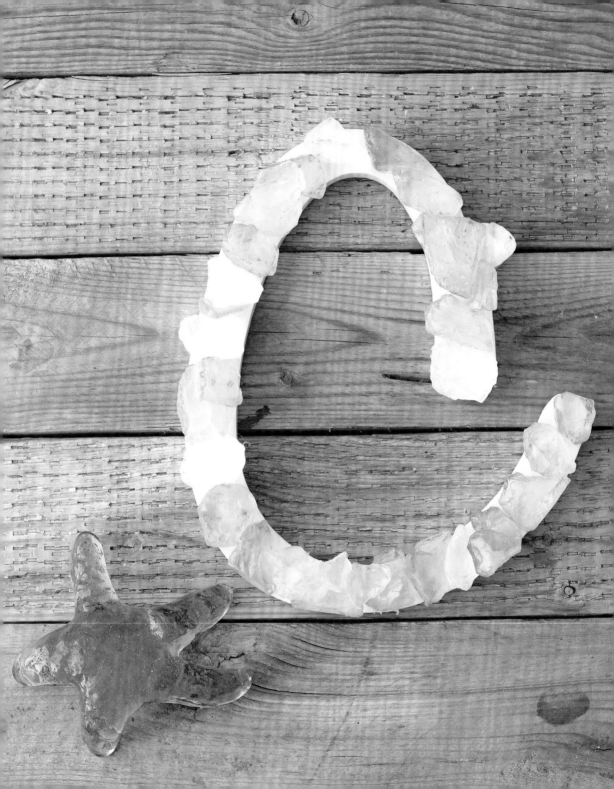

beach glass

From sky blue to aqua, turquoise to teal, and navy to indigo, blues represent the beautiful colors of our seas and lakes and sky. I love collecting beach glass at some local, small island beaches, so it brings to mind days spent in the sand and sun, smelling the salt of the ocean, exploring the tide pools, and enjoying the peace that only water can bring. Covering a handwritten-style wood letter in beautiful beach-glass stones is the perfect way to keep this feeling close no matter where you are. For the background color here, use white paint if you don't want an additional color showing through the glass, or you could use blue paint if you prefer to have a bit of color peeking through any clear pieces of glass.

MATERIALS

1 wood letter of your choice

1 (2-ounce) jar white or blue craft paint

1 medium craft paintbrush

Sea glass in various sizes and colors

Hot-glue gun and glue

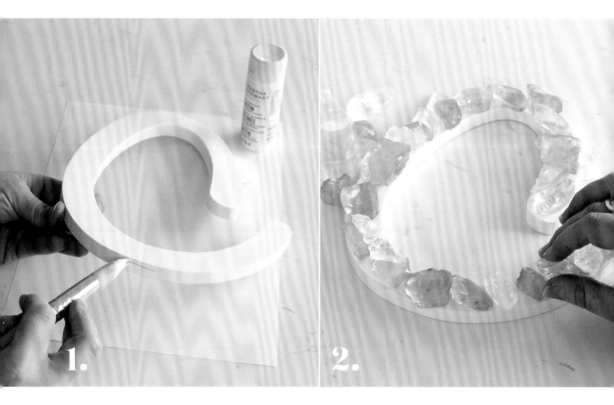

Paint the letter so that you have a solid finish on the sides and front surface.

Play with the placement of the sea glass on the letter until you find an arrangement you like. Use the larger pieces along the bottom of the letter.

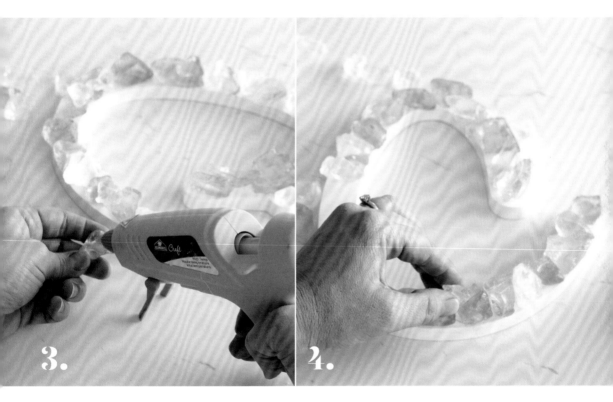

3.

One at a time, apply hot glue to the flattest area of the sea glass rocks, and then press and hold them in place briefly while the hot glue sets.

4.

Continue working your way along the letter until you have glued all the sea glass in place. After you've covered the letter with an initial layer of sea glass, overlap and glue smaller pieces to cover any little gaps between the larger pieces.

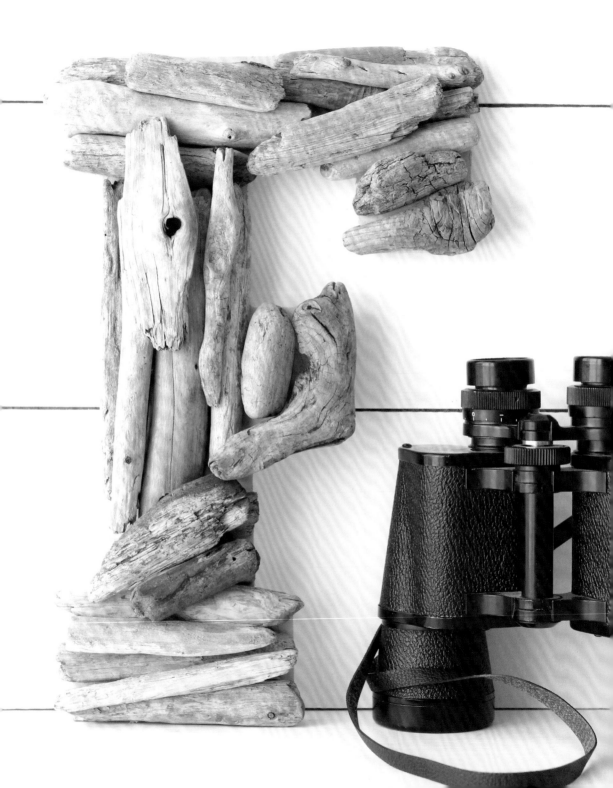

driftwood

We love collecting driftwood in our family. Every trip to the beach and visit to the lake yields small pocketfuls that we need to keep in remembrance of our amazing time together as a family. And what better way to immortalize those memories than by creating a family monogram using driftwood? The neutral tone and beautiful rustic texture make this drift-wood letter a beautiful addition to almost any décor, suited but not limited to beach and coastal styles. Block-style letters may be easiest to work with here, and when choosing a paint color, opt for one that is similar to your driftwood to camouflage any gaps in the final arrangement.

MATERIALS

1 wood letter of your choice

1 (2-ounce) jar driftwood-colored craft paint

1 medium craft paintbrush

Small driftwood pieces

Hot-glue gun and glue

1.

Give the front, sides, and back of the letter one or two coats of craft paint, and let dry.

2.

Practice laying out your driftwood until you find an arrangement that works best with its shapes and with the shape of your letter.

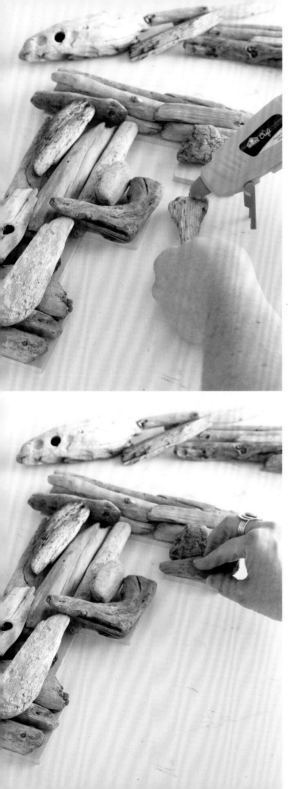

3.

Starting with the larger driftwood pieces, use your hot-glue gun to attach the driftwood pieces one at a time to the base of the letter, holding each piece in place as you go until the hot glue sets.

4.

Layer smaller pieces over the base layer of driftwood in order to build up the texture of the letter and to cover gaps.

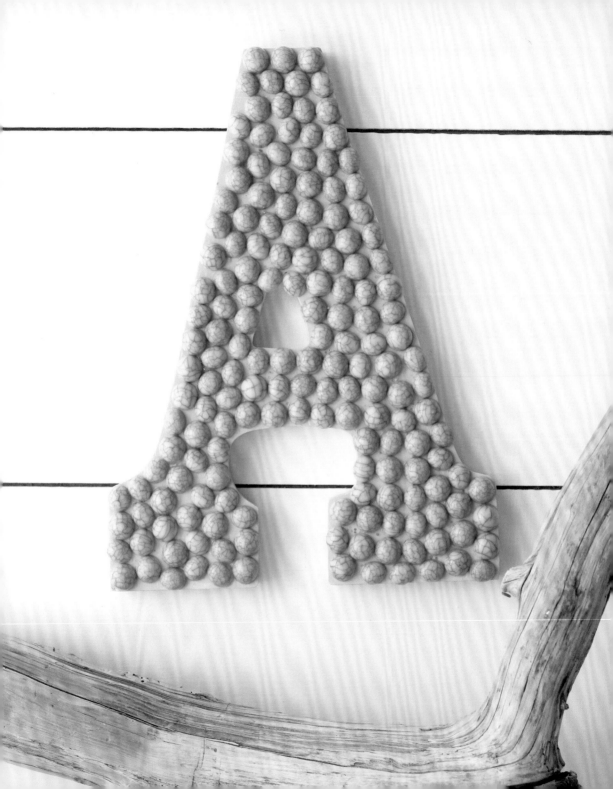

turquoise beads

I love turquoise! When we were just out of university, my husband and I backpacked around Europe, and one of the things that stands out most in our memory is the stunning turquoise water of the Greek Islands. Covering a wood letter with faux turquoise beads is a simple and beautiful way to bring a pop of beachy color into your décor, and the texture created by the veined beads imparts a rustic and natural feel. This letter would be equally beautiful displayed on a shelf or mantel, or featured on a beach- or vacation-themed gallery wall. For this project, I used beads with a flat bottom.

MATERIAL

1 wood letter of your choice

1 (2-ounce) jar turquoise craft paint

1 medium craft paintbrush

Faux turquoise beads

1 small jar clear-drying craft glue

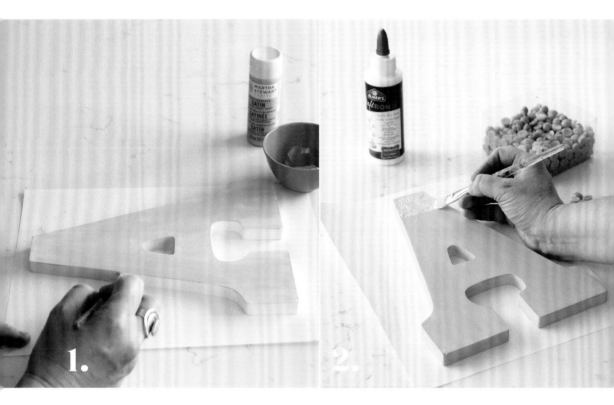

1. Apply one or two coats of turquoise craft paint to the front and sides of your letter, and let dry thoroughly. Once dry, try out various bead arrangements to determine which placement looks best.

2. Apply a layer of craft glue to the letter.

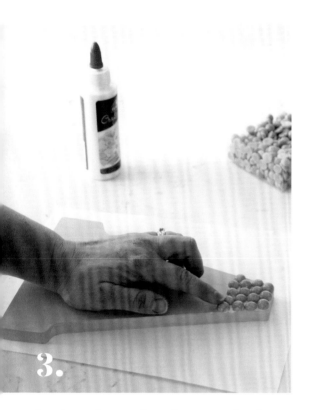

3.

Starting at the top of your letter, press beads gently into place, holding them for a moment as they set slightly. Once all the beads are in place, let the glue dry thoroughly before moving or jostling the letter.

NOTE: *This project would work beautifully with any type of flat bead that suits your décor.*

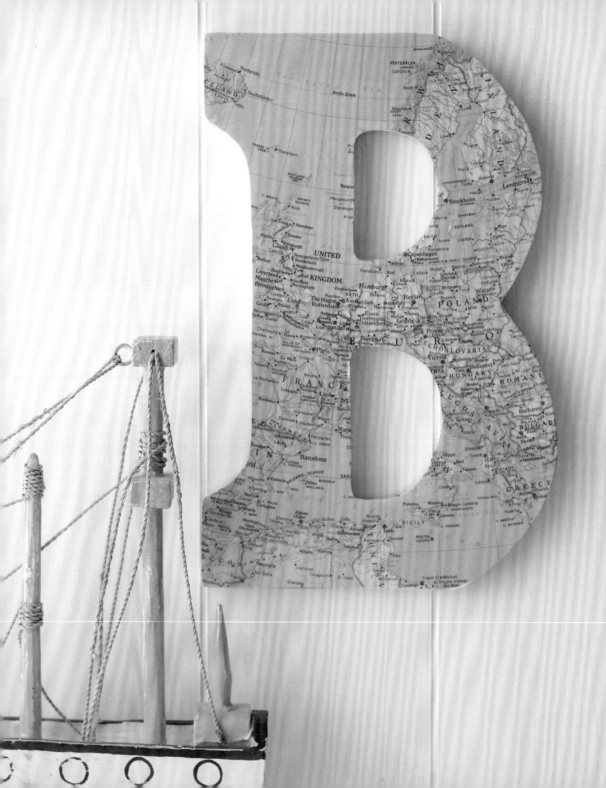

maps

I love maps. I've even covered a wall of our home in maps torn out of an old thrift-store atlas. Maps draw me in; it's easy to lose yourself exploring their boundaries, even if only in your imagination—reading all the names of cities, towns, regions, lakes, rivers, and mountain ranges, all the places you'd love to visit and explore one day. The perfect way to add interest to a plain wood letter, the maps you choose can also have special meaning to you or a friend or family member. They may represent places they've been or places they want to go, and map letters make for a wonderful gift idea. They are also well suited to coastal and beach décors, as they are naturally connected to nautical style. Map letters would be perfect for spelling out words such as *explore, dream,* or *travel.* When selecting your paint color here, choose one that will blend well with the main colors in your map.

MATERIALS

1 wood letter of your choice

1 (2-ounce) jar blue craft paint

1 medium craft paintbrush

Maps or nautical charts

Pencil

Scissors

1 (2-ounce) jar matte Mod Podge

1 Mod Podge brush

1.

Apply one or two coats of craft paint to the edges of your letter, and let dry.

2.

With the map right-side up, trace the letter onto the map with a pencil, and then cut it out using sharp scissors.

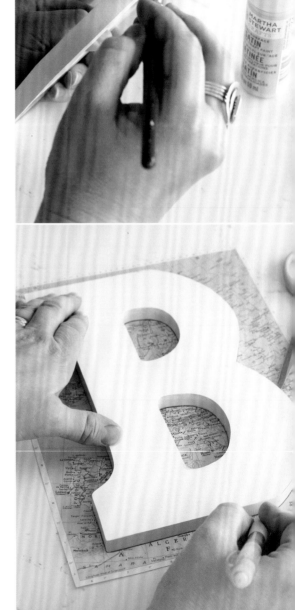

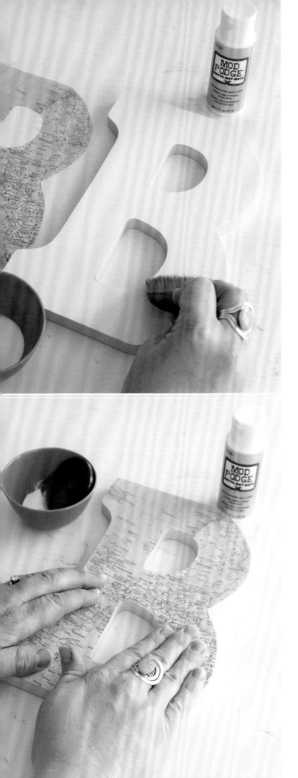

3.

Apply Mod Podge to the surface of the letter using a Mod Podge brush.

4.

Press the map onto the letter surface, and hold in place briefly while it sets. Let the letter dry completely. You can add a finish coat of matte Mod Podge after the letter is dry for extra protection from water and wear.

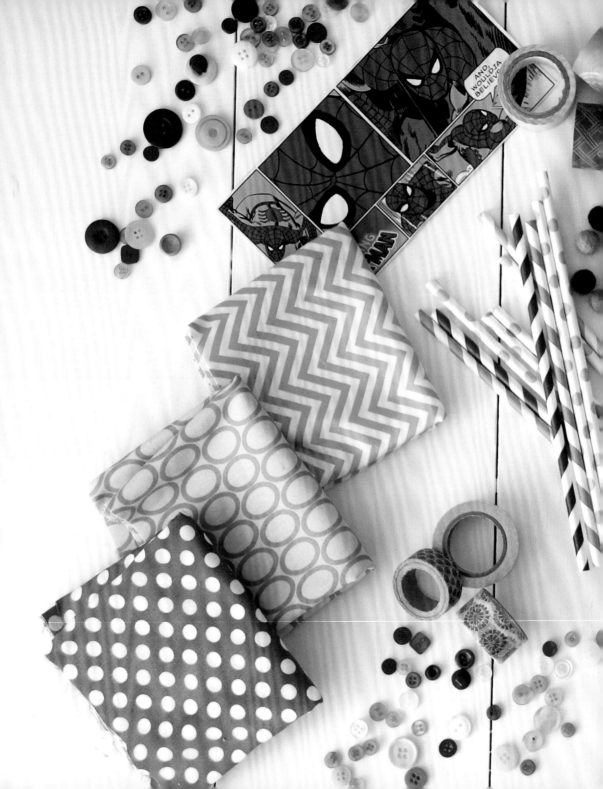

02

CUTE AND CHEERY

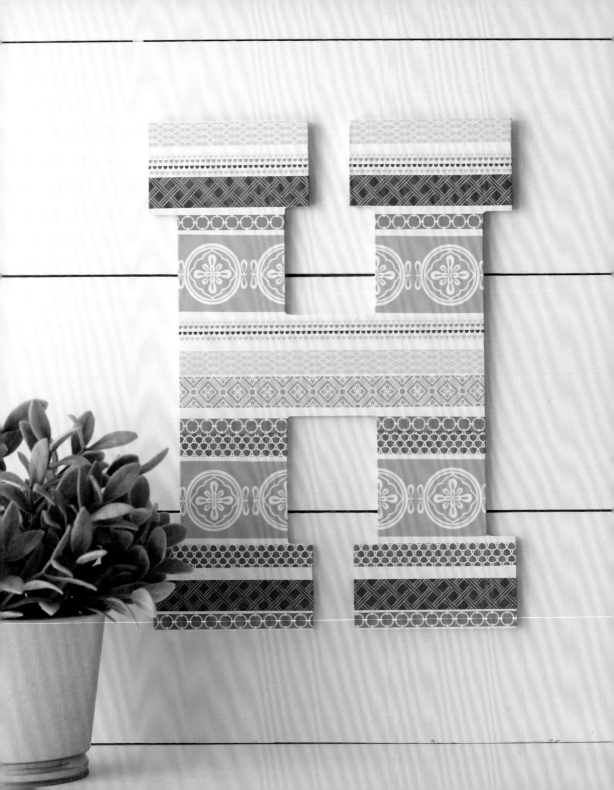

washi tape

Few craft materials can compete with the endless variety of beautiful patterns, colors, and designs of washi tape. If you aren't familiar with it, washi tape is decorative tape originating from Japan. Now hugely popular around the world, it makes for a very simple way to embellish all kinds of craft projects, from homemade cards to wood letters. The best part is, you can personalize this design in any way based on the washi tape and paint colors you choose. (I chose white paint so as not to compete with all the beautiful colors in the washi tapes I'd selected.) A letter like this would be the perfect addition to a child's room, a great gift for a baby, or even a fun birthday present. This washi-tape letter is one of my favorites, and I can't wait to give it to my fun "H" friend!

MATERIALS

1 wood letter of your choice

1 (2-ounce) jar craft paint in white or the color of your choice

1 medium craft paintbrush

3 to 5 rolls washi tape in the colors/patterns of your choice

Scissors

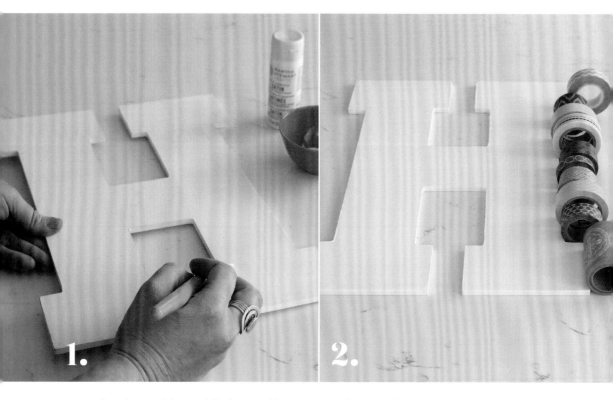

1.

Cover the edges and front of the letter with one or two coats of craft paint, and let dry thoroughly.

2.

Gather together the washi tape, and play around with your design and the order in which you want to attach it.

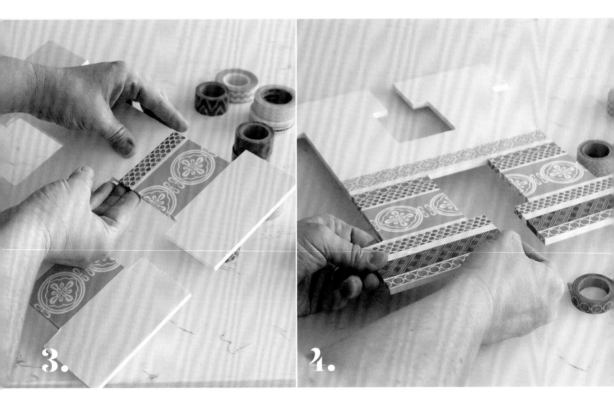

3. Starting near the bottom of the letter, press the first piece of washi tape down onto the letter, keeping it as straight as possible and making sure the edges are firmly adhered. Cut the tape at the back of the letter, or line it up and have the edges meet at the back if you want the back to be covered as well.

4. Cover the bottom of the letter, then continue working your way up the letter with strips of washi tape, making sure to keep the lines as straight as possible.

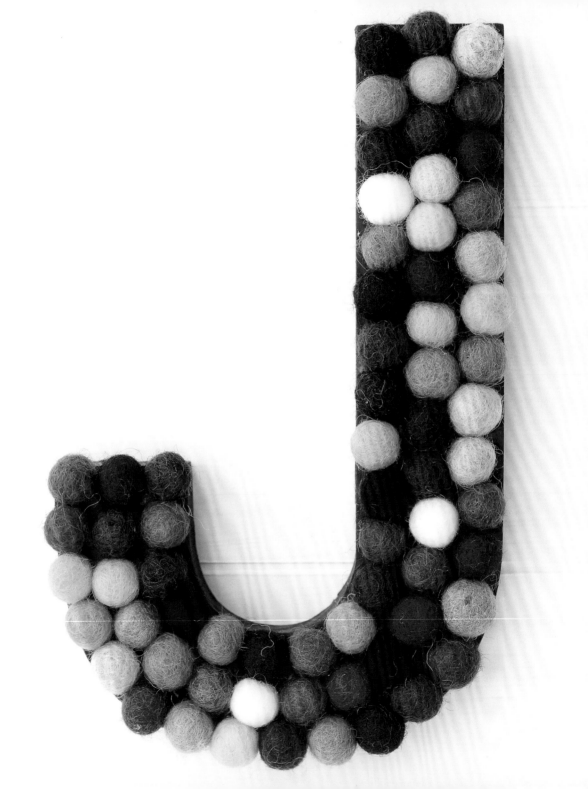

felt balls

Did you know that felting wool is actually an ancient craft, older even than weaving? Possibly this is because it is so simple: you only need to add heat, pressure, and a little bit of moisture to a piece of wool. In existence for hundreds of years and found throughout multiple areas of the world, felt has been used for clothing, for decoration, for shelter, and even to create early armor. Now commonly used for crafts and home décor, felt balls provide a fresh and adorable way to decorate a wood letter, or even several letters to spell out a child's name or a word for your playroom, like *play*, *fun*, *learn*, or *read*. The number of felt balls needed will vary based on the size of your letter. This example uses 68 felt balls for a 6-inch-tall letter J. If your letter is much larger, you may need more balls or may even wish to use 2-cm felt balls.

MATERIALS

1 wood letter of your choice

1 (2-ounce) jar craft paint in the color of your choice

1 medium craft paintbrush

1-cm felt balls (amount will vary)

1 small bottle white quick-drying, clear-drying craft bond glue

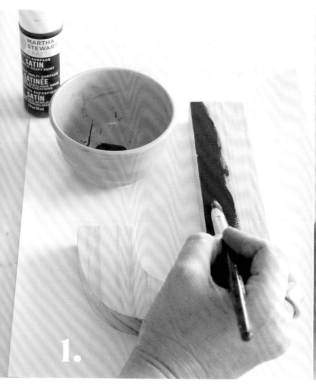

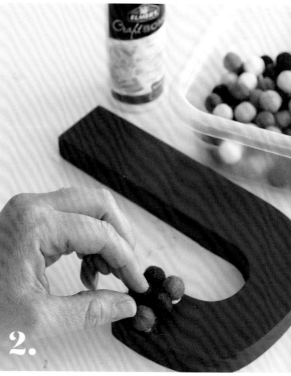

1.

Apply two base coats of the craft paint to the front, sides, and back of your letter, and let dry thoroughly.

2.

Practice arranging the felt balls on the letter to get a feel for the design you like. Once you like the placement, begin to glue the balls in place one at a time, putting a dab of glue on the back of each.

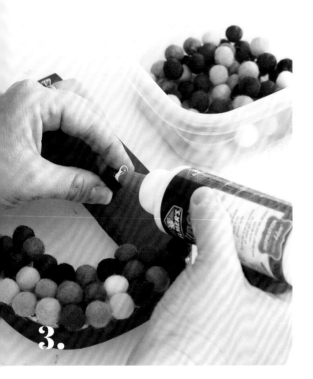

3.

As you work your way up the letter, be sure to hold each felt ball in place for a few moments to help it adhere before moving on.

NOTE: *While white craft glue is best for this project because it allows for some flexibility and movement as you build your letter, it is also important to not jostle or move the letter very much until all the glue has dried and the felt balls are fully adhered.*

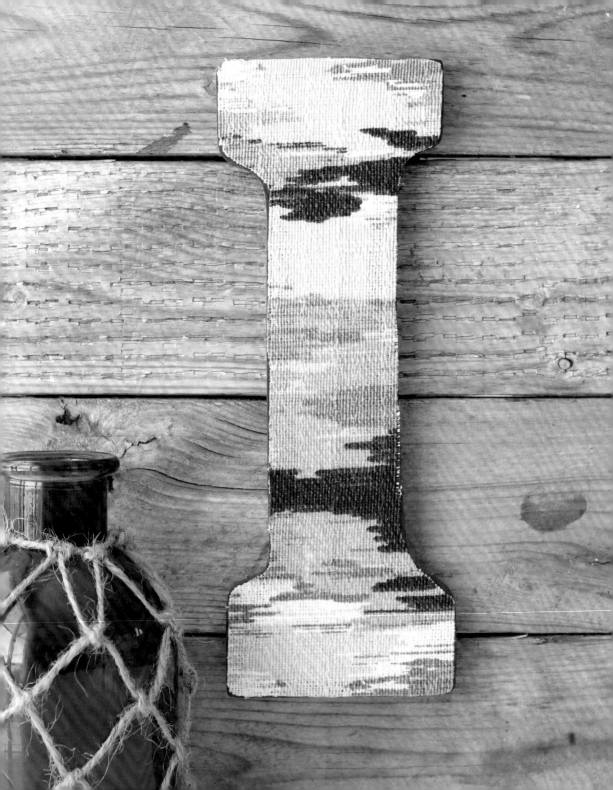

fabric

"Each of us is a unique thread, woven into the beautiful fabric of our collective consciousness."
—Jaeda DeWalt

Few craft materials are as commonly available as, and have the infinite range of varieties of, fabric. The sky is truly the limit when using fabric to cover a wood letter, and you are limited only by your imagination or by what is readily available to you. You could use home décor fabric, quilting fabric, vintage fabric, or even faux fur, depending on the style and effect that you want. One of the simplest in the book, this project can be reinterpreted in so many ways that it will never get old.

MATERIALS

1 wood letter of your choice

1 (2-ounce) jar white craft paint or the color of your choice

1 medium craft paintbrush

Fabric

1 felt pen or piece of chalk in a color that coordinates with the fabric

Fabric scissors

1 (2-ounce) jar matte Mod Podge

1 Mod Podge brush

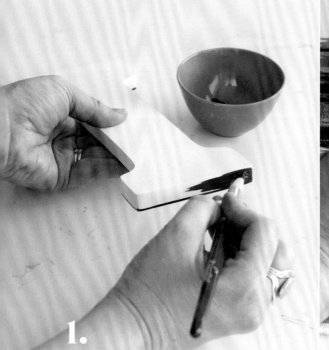

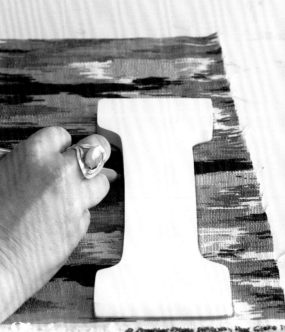

1.

Cover the edges of your letter with one or two coats of the craft paint, and let dry thoroughly.

Place the letter on the fabric, which should be right-side up. Trace the outline of the letter onto the fabric with the felt pen, or use chalk as it will easily wipe off the fabric.

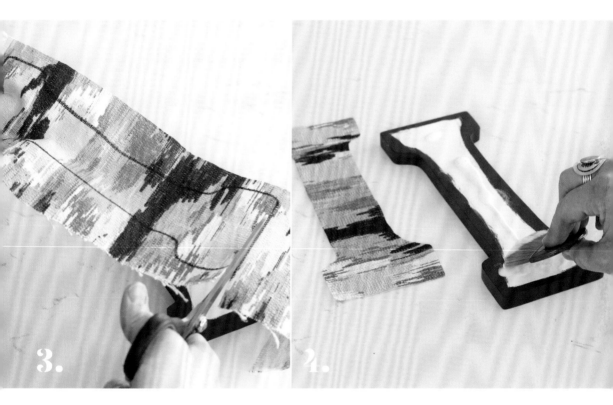

3. Cut out the fabric along the outline of the letter that you just drew.

4. Apply Mod Podge to the letter using the Mod Podge brush, and press the fabric onto the letter, lining up the edges as evenly as possible.

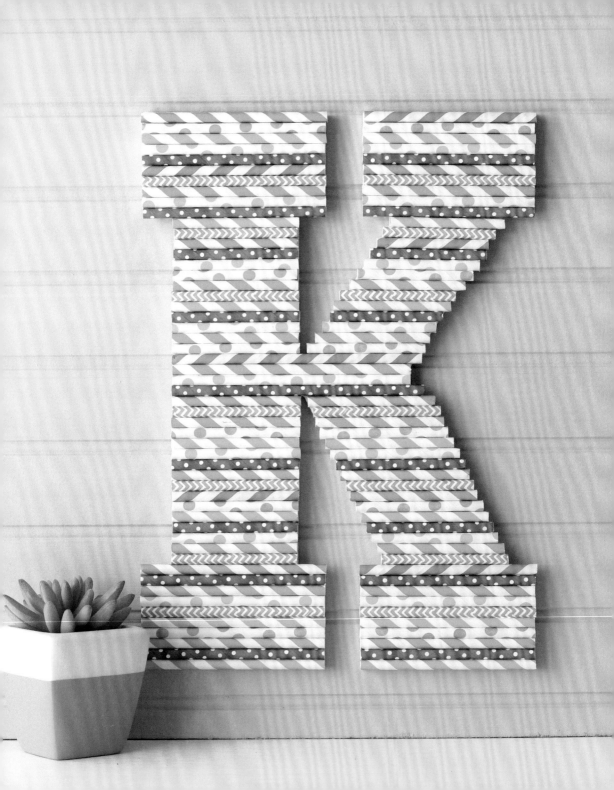

colored straws

Paper straws remind me of sipping cold, refreshing beverages outdoors on beautiful, sunny summer days. Whenever I see paper straws in craft stores, I'm drawn to the sheer variety of their colors and patterns. Some are as beautiful as fabrics! And why not use them to create a fun and fresh letter? You could easily mix the patterns and colors, like I did, or stick to a more consistent design with one pattern. Use paper straws to make a letter for a special child or friend in your life, or to add some cheery color to your kitchen by spelling out a related word, like *eat, drink,* or *chow.*

MATERIALS

1 wood letter of your choice

1 (2-ounce) jar white craft paint or the color of your choice

1 medium craft paintbrush

1 to 2 packages paper straws, depending on letter size

Sharp scissors

1 small bottle tacky, clear-drying white craft glue

1.

Apply a coat of paint to the edges of your letter, and let dry.

2.

Cut the first straw to size with sharp scissors. Starting at the bottom of the letter, use tacky glue to put it in place, holding it down briefly to help it set.

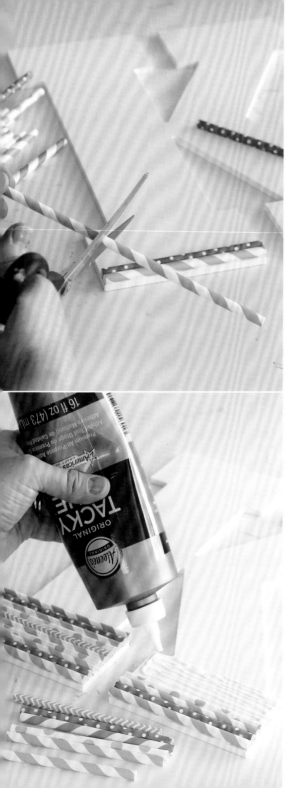

 3.

Measure out a few straws at a time, cutting them to size and gluing them in place, working up from the bottom of the letter. The tacky glue works well for this project because it allows for some flexibility and movement as you place the straws.

4.

Continue until you have reached the top, making sure to keep the straws as straight as possible and aligned correctly as you work your way up.

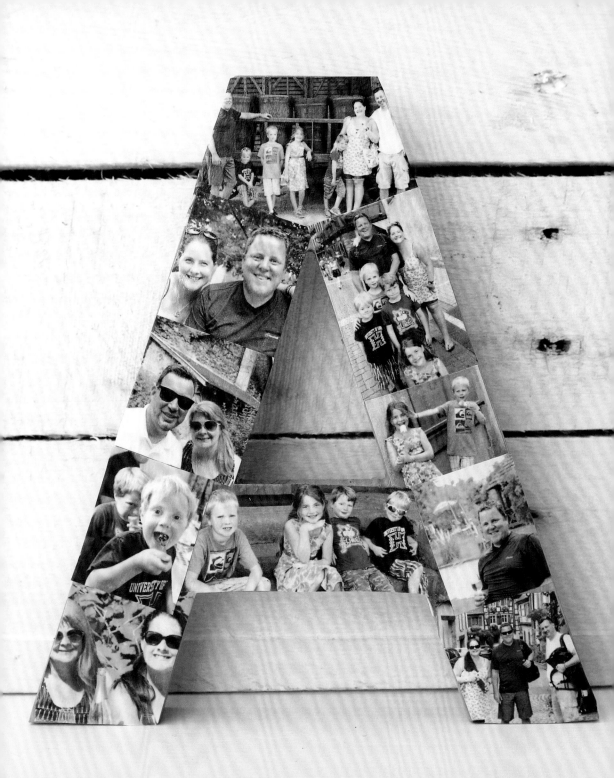

photo collage

Photographs! We love them! Our society has become absolutely bombarded with photographic images since the development of phone cameras and online social media sites. Daily life is being recorded at a pace never before seen, our special memories being saved right alongside pictures depicting our simple daily lives. But despite their overwhelming prevalence, photographs remain a beautiful way to immortalize important moments, events, and trips. A wood-letter photo collage of a special event or occasion makes a perfect gift and is equally at home displayed in your own space on a bookshelf or gallery wall. To create this letter, I first made a photo collage using an online program called PicMonkey. I then printed it out on a regular household ink-jet printer on regular printer letter-size paper.

MATERIALS

1 wood letter of your choice

1 (2-ounce) jar craft paint or stain in the color of your choice

1 medium craft paintbrush

Dry, lint-free cloth (if using stain)

Sharp scissors

Printouts or photocopies of photographs

1 (2-ounce) jar matte Mod Podge

1 Mod Podge brush

Paint or stain the edges and front of your letter, and let dry thoroughly. If using stain, once the stain has dried for a short time, wipe off the excess with a dry, lint-free cloth.

Cut your photos carefully around the edges, and play with their arrangement on the letter. Fold down the edges of each photograph to determine where to cut so that the photos line up with the edges of the letter, and cut each one to size.

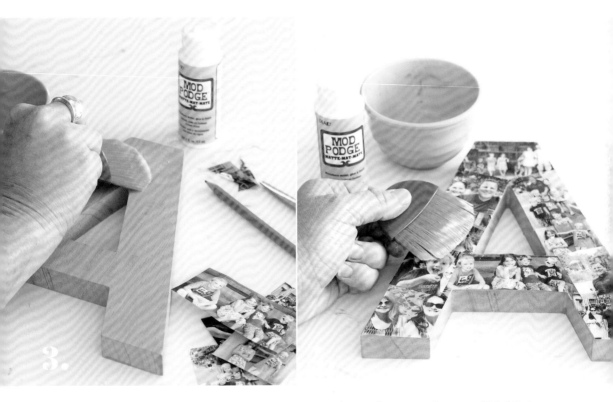

3.

Apply Mod Podge to the letter using the Mod Podge brush, and gently place each photograph in its spot, making sure to carefully line up the edges.

Once dry, apply a protective coat of Mod Podge over the letter to prevent the inks in the printed photographs from running in the event of contact with water.

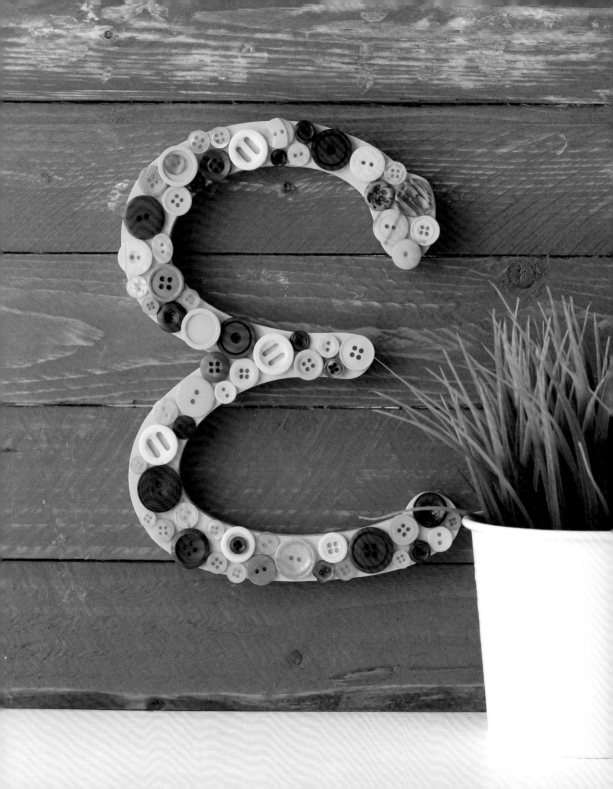

buttons

Buttons provide such an adorable way to add layers of texture and color to wood letters. I've created many button monogram projects as baby gifts over the years; but in addition to being a perfect way to decorate a nursery or child's room, a button letter would also be cute in a craft or laundry room. While letters covered in plastic buttons result in a cheery and youthful look, you could select wood, metal, or shell buttons for a more mature design. Button letters would be perfect for spelling out a name or for words like *create, craft, sew,* or *wash.* Designwise, the roundness of the buttons works well with a scroll- or handwriting-style letter font. Pick a paint color that works with your button color choices. And keep in mind that the amount of buttons needed will vary based on the size and shape of your letter and your buttons.

MATERIALS

1 wood letter of your choice

1 (2-ounce) jar craft paint in the color of your choice

1 medium craft paintbrush

Buttons in your choice of color and styles

1 small jar white clear-drying craft glue

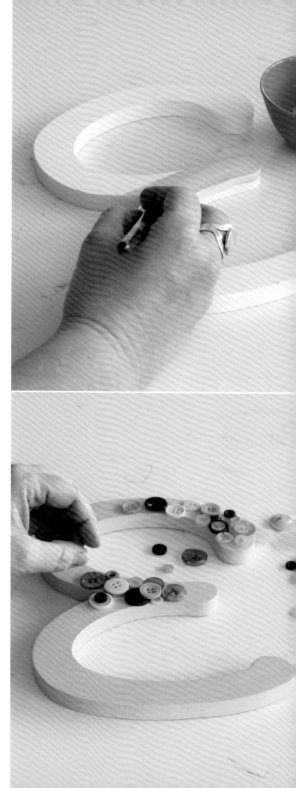

1.

Cover the edges and front of your letter with one or two coats of the craft paint, and let dry.

2.

Practice placing the buttons on the letter until you come up with an arrangement you like.

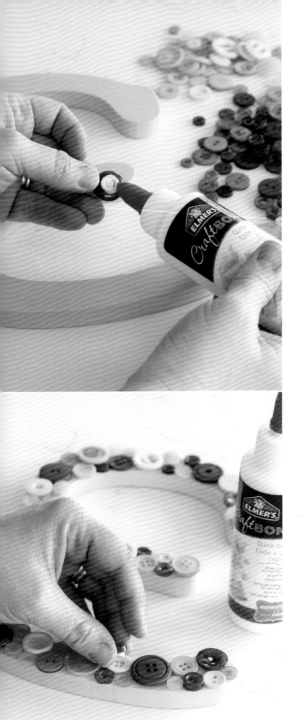

3.

Using craft glue on the back of each button, start applying a base layer of buttons, holding each button in place for a moment to help it set.

4.

Then overlap and layer with additional buttons to add dimension and cover blank areas.

NOTE: *Tacky craft glue works well for projects like this in which you need some flexibility while placing the material or items being applied to the letter surface.*

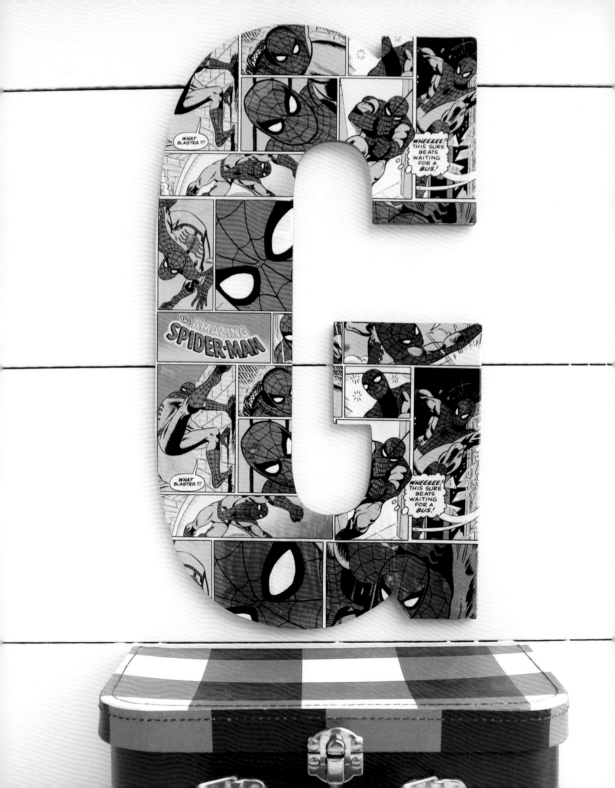

comic book paper

Comic book art has a fun, graphic appeal that's hard to match. Popular with both adults and children, contemporary comics are printed in crisp colors and at high resolutions, making them perfect for decorating wood letters. Often loved with cult-like appreciation, superhero comics are hugely popular with children and teens. Whether intended for an adult or a child, this letter is sure to make a perfect addition to any comic book fan's bedroom and would be a much-loved gift. Comic book letters would be perfect for use in spelling a name or words like *pow, bam, zap,* or *boom.* For this project, I downloaded the comic book paper online via Etsy and printed it out. I suggest paint colors such as dark blue, black, or gray here, but you can choose any color you like.

MATERIALS

1 wood letter of your choice

Comic book pages or printouts

1 (2-ounce) jar craft paint

1 medium craft paintbrush

Pencil

Scissors

1 (2-ounce) jar matte Mod Podge

1 Mod Podge brush

1.

If you have printed your paper and it's too short to accommodate the full size of your letter, overlap it to determine where you want to connect the sections.

2.

If needed, cover the edges of the letter with one or two coats of the craft paint, and let dry thoroughly. Place the letter on the comic book pages or printouts, right-side up, and use a pencil to trace the outline of the letter onto the paper. Cut out the letter with sharp scissors.

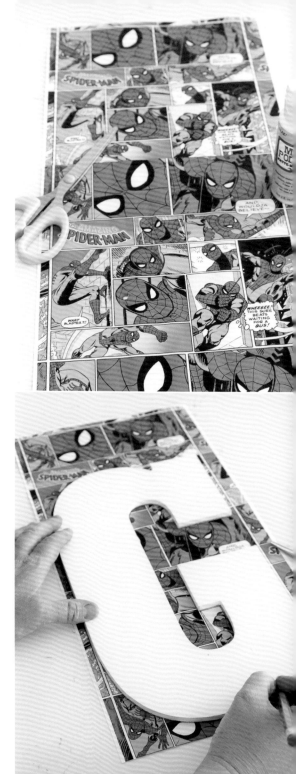

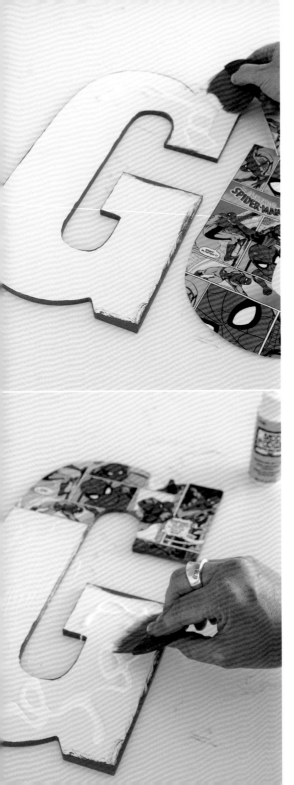

3.

Apply the Mod Podge to the letter using the Mod Podge Brush.

4.

Gently apply the comic book pages to the letter, making sure to line up the edges of the paper evenly with the edges of the letter. Work your way down the letter, carefully piecing together any multiple sections of printed comic book paper and adhering them with Mod Podge.

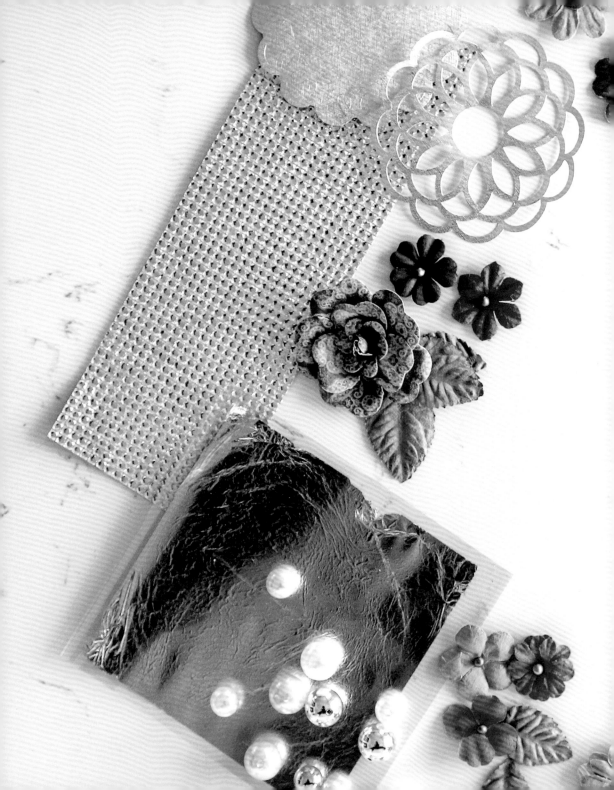

PRETTY AND GLAM

gold leaf

As a child, I remember my mother spending hours refinishing an old, secondhand mirror frame using gold leaf. She painstakingly applied gilding medium followed by the thinnest sheets of gold leaf and brushed away the excess to give a tattered secondhand find a stunning new lease on life. This mirror still hangs in her dining room today, and few techniques can compete with the glam or beauty of genuine gold leafing. Available at craft stores, gold leaf is actual real gold that has been hammered into extremely thin sheets and is available in a variety of shades and gold karats. It can be applied to a variety of surfaces for a real gold finish. Used to gild a wood letter, gold leaf can feel expensive and luxurious or cheery and fun, depending on the background paint color. You can choose a color similar to the metallic leaf or one that contrasts strongly with it.

MATERIALS

1 wood letter of your choice

1 (2-ounce) jar craft paint in the color of your choice

2 medium craft paintbrushes

1 small bottle gilding adhesive

1 to 2 sheets gold (or other metallic) leaf

1 gilding brush

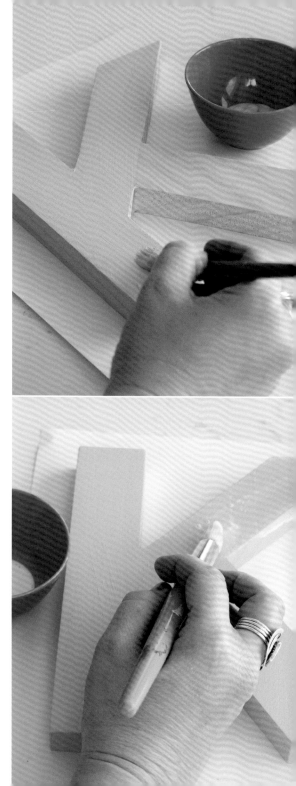

1.

Cover the base and edges of the letter with one or two coats of the craft paint, and let dry thoroughly.

2.

Using a clean, dry craft paintbrush, cover one section of the letter with the gilding adhesive. Leaving areas of the letter without gilding adhesive will create a spottier final appearance.

3.

Press a sheet of metallic leaf onto the adhesive, and remove the wax paper backing. You can overlap the sections of metallic leaf as you move along the letter and add more gilding adhesive.

4.

Go over the letter with a gilding brush once all the sections have been gilded to remove any excess and reveal some bits of the paint color below.

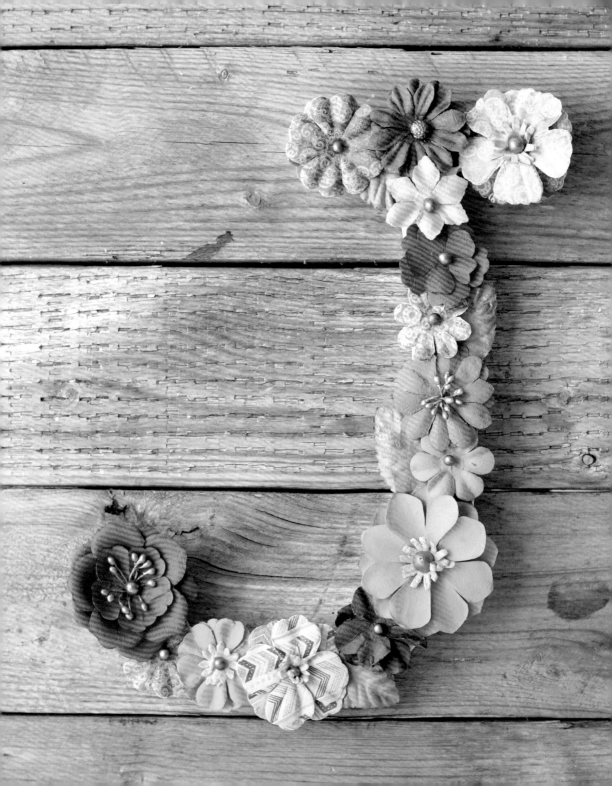

paper flowers

"Earth laughs in flowers." —Ralph Waldo Emerson

One of the first wood-letter projects I ever created was a flower letter that I made when I was helping a friend decorate her daughter's bedroom. We have two sons, so it was a fun treat to work with paper flowers to make a stunning, feminine letter to hang above a young girl's headboard. With this project, you are limited only by the style of flowers you select. Paper flowers are now available in a wide variety of colors and designs, so you can find sets to suit almost any décor or taste—and can tailor this letter specifically to the person for whom you are creating it. The fresh, bohemian look of the flowers here are perfect for a nursery or tween's room. By varying the paper flowers, you can create letters to suit vintage or farmhouse décor styles as well. And you can cover a letter completely with flowers or alternatively place flowers only on certain areas of the letter. Paper-flower letters would be beautiful spelling out words such as *bloom, laugh, love,* or *joy.* A scroll- or handwriting-style font works well here. Note that the flowers I selected already had beaded centers, but if you choose flowers without beaded centers, you can add small beads once the flowers have been glued down and the glue is dry, in order to give the design a more finished feel.

MATERIALS

1 wood letter of your choice

1 (2-ounce) jar craft paint in the color of your choice

1 medium craft paintbrush

1 package paper flowers

1 small bottle white clear-drying craft glue

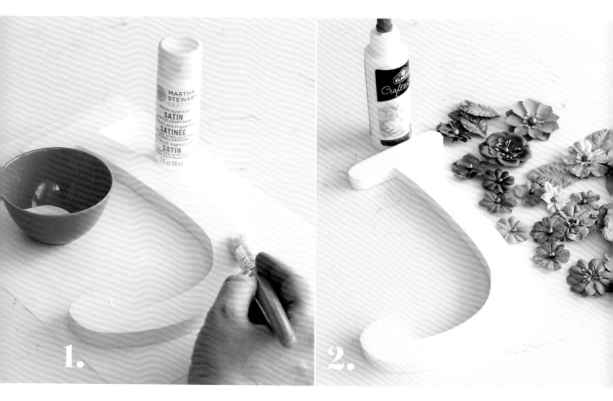

1.

2.

Cover the edges and face of the letter with one or two coats of the craft paint, and let dry thoroughly.

Lay the flowers out and play with the design to find an arrangement that you like.

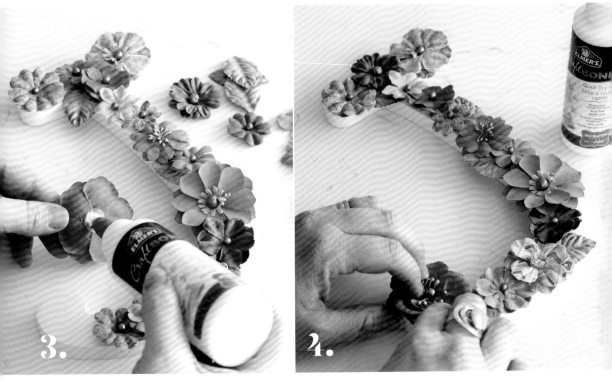

3. Dab the craft glue onto the back of the flowers, one at a time, and press them down on the letter. Hold them in place briefly to help them set up.

4. Continue working your way down the letter until you've covered the entire front surface with flowers.

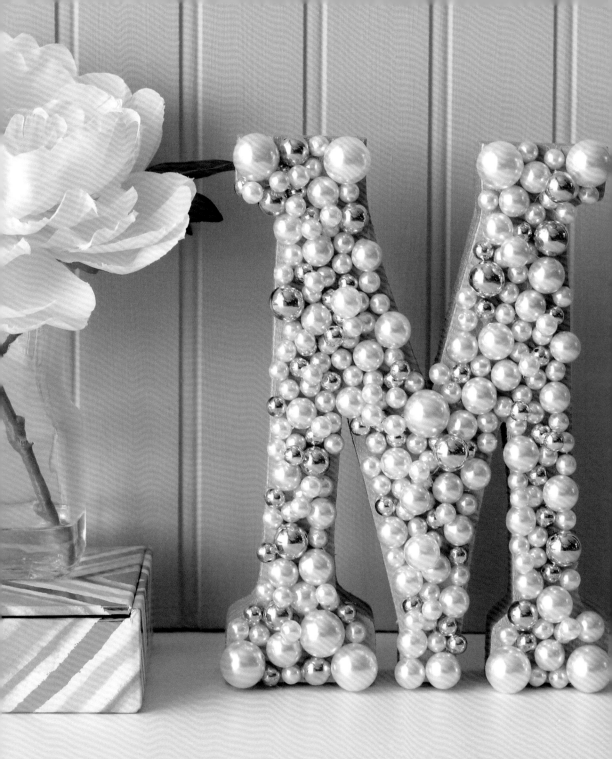

pearl beads

"What strikes the oyster shell doesn't damage the pearl." —Rumi

Few objects have been as highly valued and admired over time as natural pearls. They have become symbolic of rarity, beauty, and glamour. The iridescent quality of pearls is one of their most sought-after characteristics, and the natural glow of pearls evokes feelings of richness and luxury. Equally at home displayed on a shelf or mantel or hanging on a wall, this pearl-covered letter is the perfect way to add a touch of classic glamour to your décor. Pearl letters would be perfect for spelling out words like *seek*, *find*, or *precious*. When considering a paint color here, choose one that coordinates well with the color of the pearl beads you've selected.

MATERIALS

1 wood letter of your choice

1 (2-ounce) jar craft paint in a pearl or gold color

1 medium craft paintbrush

Faux pearl beads

Hot-glue gun and glue

1.

Cover the front and sides of the letter with one or two coats of the craft paint, and let dry thoroughly.

2.

Starting with some larger beads on the bottom corners, begin to apply the beads to the surface of the letter. Glue them onto the letter using the hot-glue gun. (You will need to hold them down briefly as the hot glue sets.) Alternate the sizes as you work to create an interesting, random design.

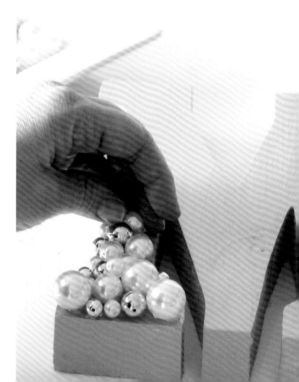

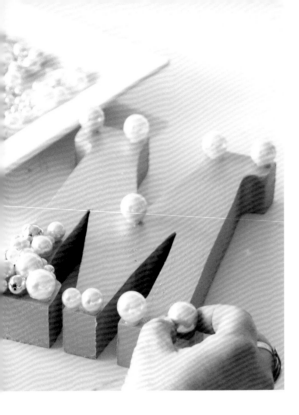

Glue larger beads onto each of the corners of the letter so that the edges of the shape stand out more clearly. Build up the application with the rest of the beads. Once the face of the letter is full, overlap with some of the smaller beads to create a more layered effect.

NOTE: *You can opt for pearl beads with a flat bottom. And, you could create a similar project using other styles and colors of beads.*

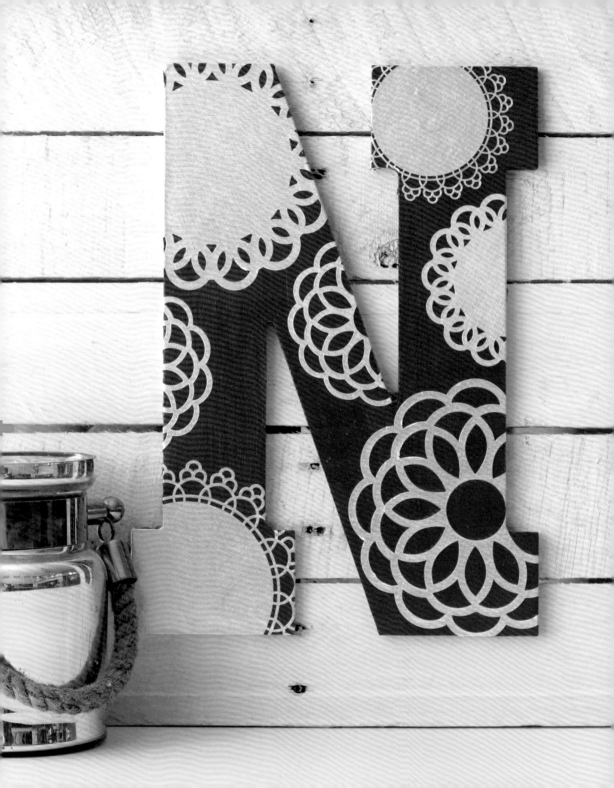

silver doilies

While white doilies evoke a traditional feel, their intricate designs are also full of detail and beauty. I created this combination of modern metallic-silver doilies contrasted with a dark pink paint color for the bedroom of a friend's daughter. Alternatively, you could use traditional white doilies layered over a soft paint color or even a watercolor-painted letter. Made with white and pastel paint tones, a doily-covered letter would be beautiful for seasonal spring décor or to spell words such as *Easter, hope, joy,* or *bloom.*

MATERIALS

1 wood letter of your choice

1 (2-ounce) jar craft paint in white or the color of your choice

1 medium craft paintbrush

Craft doilies in the color of your choice

1 (2-ounce) jar matte Mod Podge

1 Mod Podge brush

Craft scissors

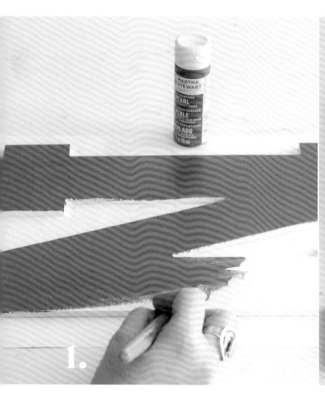

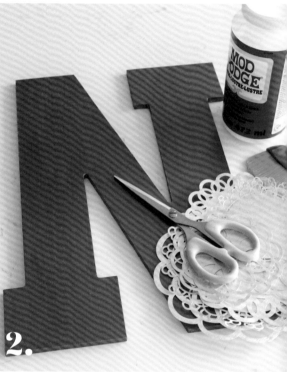

1. Cover the front and edges of your letter with one or two coats of craft paint, and let dry thoroughly.

2. Position the doilies on the surface of the letter to come up with a design that you like. Use some whole doilies and some portions of doilies.

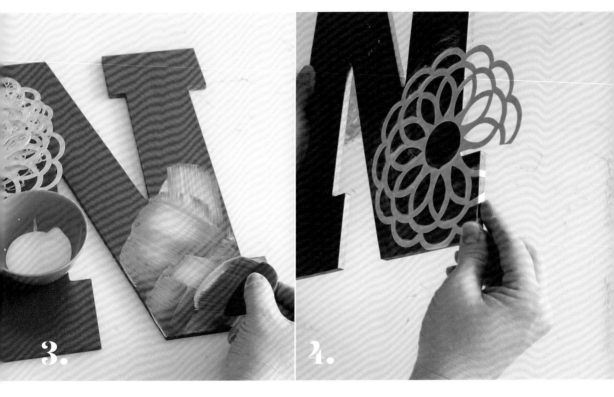

3.

Apply matte Mod Podge to the areas where the doilies will go using a Mod Podge brush.

4.

Press the doilies down into place, cutting them as needed, and smoothing them down along the edges of the letter as well so that they fold over the sides.

NOTE: *If you want to further protect the surface, go over the whole letter with an additional coat of matte Mod Podge to seal the doilies on the surface.*

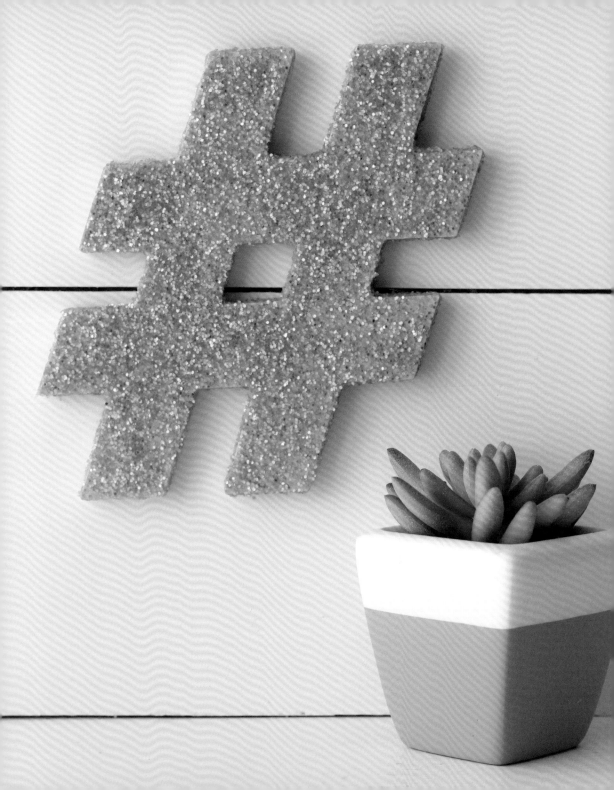

glitter

As a crafter, teacher, and mother, I certainly
know firsthand the messy chaos that can be
created by glitter! In fact, I imagine that glitter
projects are the bane of any school janitor.
Yet there remains a definite place for glitter in
crafts and home décor, as it creates a sparkly,
glam feel that few other materials can match.
For a fun and modern take on glitter, I went
with a bold color and chose a hashtag as my
"letter." This would be perfect for a youthful
bedroom, tween room, or playroom. Alterna-
tively, you could use white glitter (or "diamond
dust") to create winter-themed letters that
spell words like *snow* or *holiday*.

MATERIALS

1 wood letter or symbol of your choice

1 (2-ounce) jar craft paint that matches
your glitter

2 medium craft paintbrushes

1 small jar white clear-drying craft glue

1 piece scrap paper

1 small jar glitter in the color of your choice

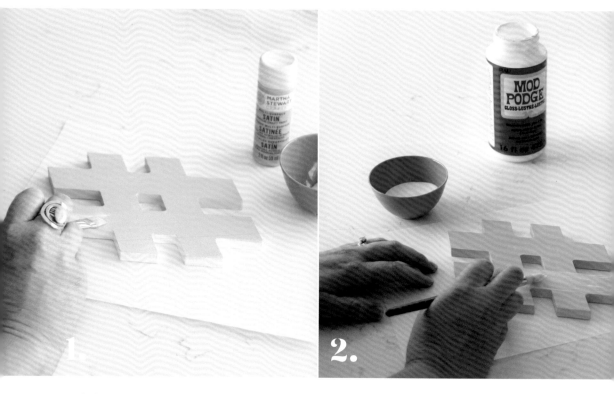

1.

Begin by covering the symbol with one or two coats of the craft paint, and let dry thoroughly.

2.

Apply the craft glue to the symbol using the second paintbrush.

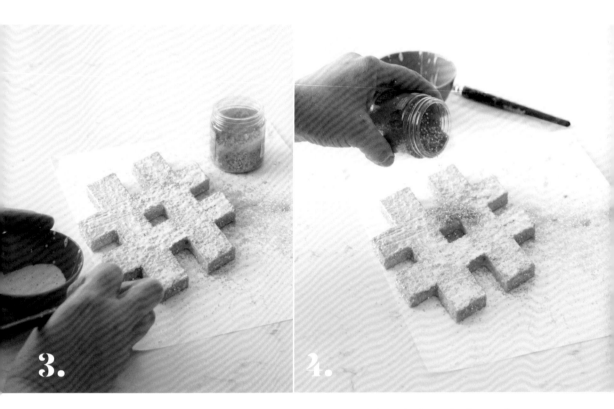

3.

Place your symbol on top of the scrap paper, and sprinkle on the first layer of glitter. Let dry.

4.

Once the first layer is dry, go back over the symbol with some more craft glue, and add a second layer of glitter to fill in the gaps and create a more textured, dynamic look.

NOTE: *Applying the glitter while the symbol is on scrap paper makes for easy cleanup; you can simply slide the excess back into the glitter container to use on another project!*

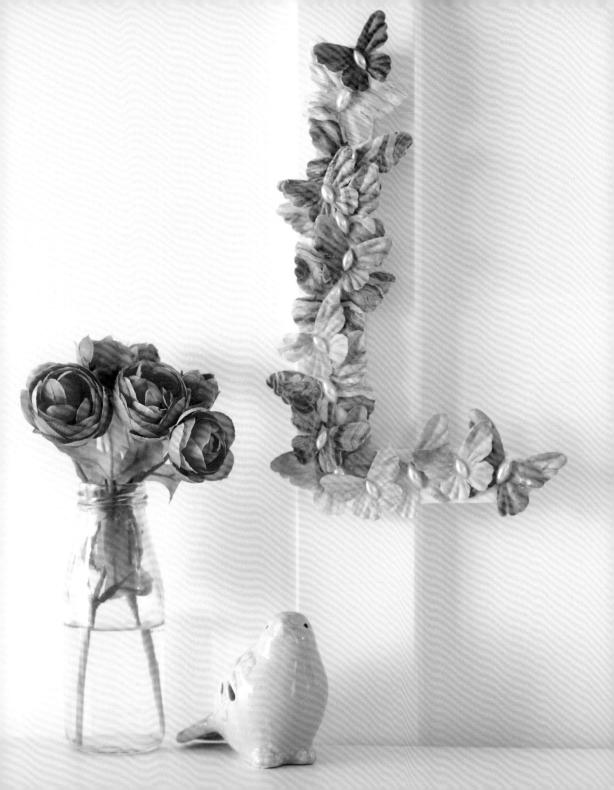

butterflies

"We are all butterflies waiting to happen."
—Anonymous

Few creatures on earth can compete with
the beauty and whimsy of a butterfly, and this
letter covered in watercolor-paper butterflies
showcases this perfectly. This letter would
be perfect for many spaces, from a beautiful
nursery to a boho-chic family space. Butterflies
are the perfect way to add love, light, and
whimsy to your décor. Butterfly letters would
be beautiful mixed together to spell words
such as *laugh, spring,* or *fly*. Scroll-style or
handwriting fonts are lovely here. For the
butterflies, I chose ones made from paper
with a watercolor-paint finish.

MATERIALS

1 wood letter of your choice

1 (2-ounce) jar craft paint in white or the color
of your choice

1 medium craft paintbrush

1 package paper butterflies

1 small bottle quick-drying, clear-drying craft
bond glue

1.

Cover the front and sides of the letter with one or two coats of craft paint, and let dry thoroughly. Then, practice placing the butterflies on the letter until you come up with an arrangement you like. Glue the butterflies onto the letter by dabbing some glue onto the back spine of each. Press them down, and hold them in place while they set slightly.

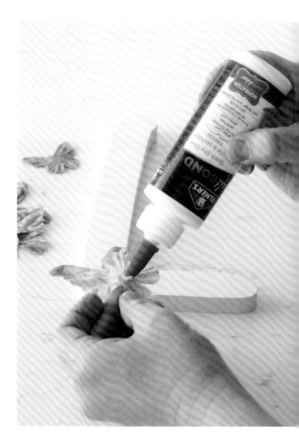

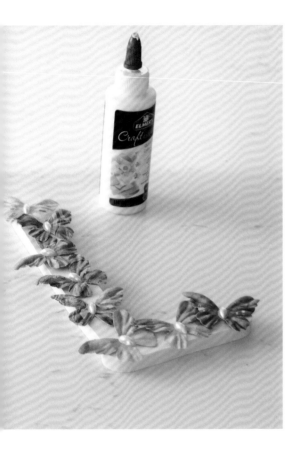

Gently overlap the wings as you glue, forming a base layer with the larger butterflies and layering the smaller butterflies on top.

NOTE: *I chose to vary the colors in a somewhat random design, but you could also use butterflies of all one color or all within one color family. An ombré design of one color family, transitioning from dark to light, would also produce a stunning effect.*

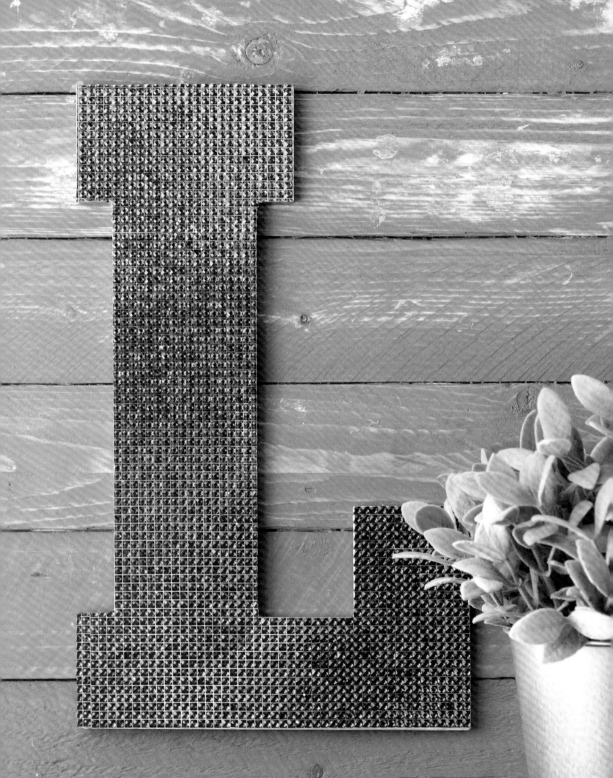

sequin sticker

This large sequin sticker letter is a fun and
bright addition to a child or teen bedroom,
or to a craft room or dressing room. Large
sequin stickers are available in several styles
and colors, making this project easy to
customize for any recipient on your gift list.
Done in a silver color, this wood letter would
create a disco-ball look that could be cute in
either a child's space or a glam living area.
Because the sequin sticker sheets are arranged
in a grid format, they work best when cut in
straight lines, so you may wish to select a
block- or straight-letter style for this project.

MATERIALS

1 wood letter of your choice

1 (2-ounce) jar craft paint in a color
that coordinates with the sticker

1 medium craft paintbrush

Sequin or sparkle sticker sheet

1 washable felt marker or chalk

Sharp scissors

X-Acto knife and cutting mat (optional)

1.

Cover the front and edges of your letter with one or two coats of craft paint, and let dry thoroughly.

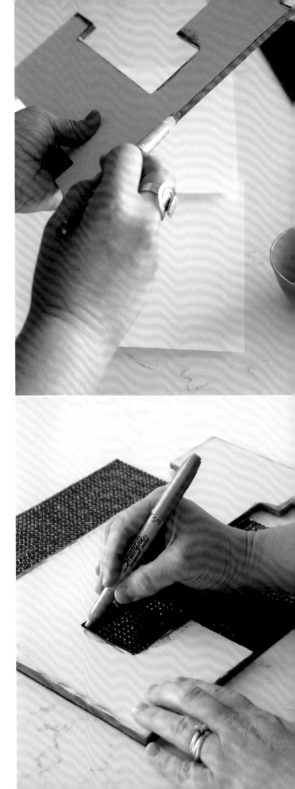

2.

With the sequin sticker right-side up, place the letter on top of the sticker, and trace the outline of the letter onto the sticker using the felt marker.

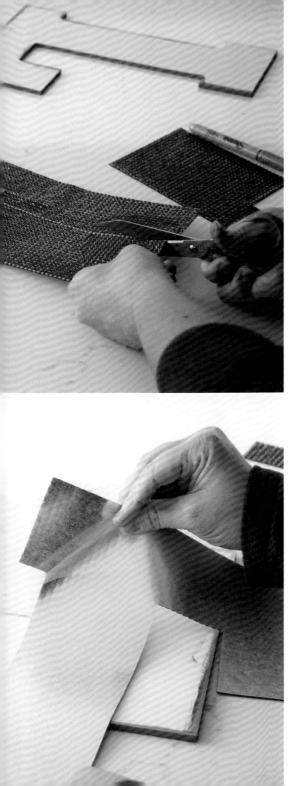

3.

Cut just inside of the line you have marked on the sequin sticker using scissors or an X-Acto knife and cutting mat.

4.

Remove the sticky backing and carefully line up the sticker on the letter, pressing it down into place.

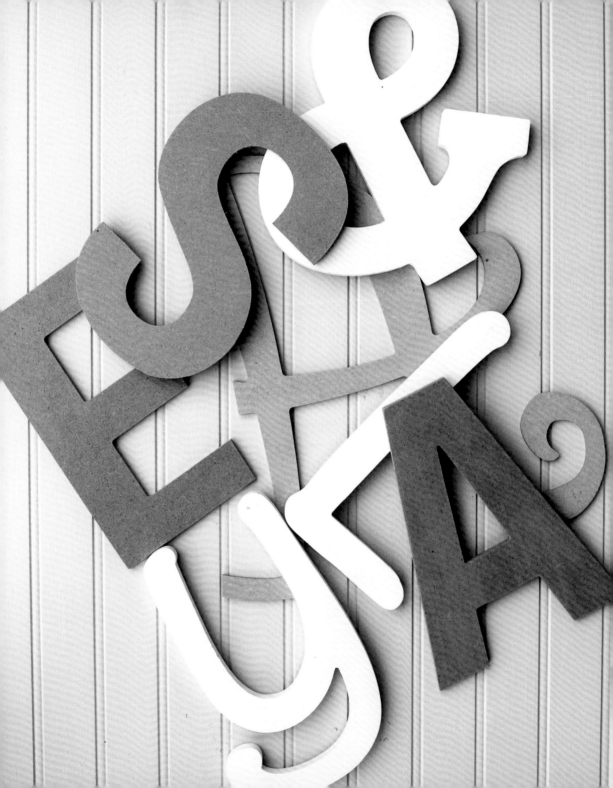

acknowledgments

I would like to thank everyone who helped and supported me along the way during this crazy journey of crafting my first book. When I began this project, I had no concept of the extent of all that is involved in writing a book or what, exactly, lay ahead. Thank you to my editor, Lisa Westmoreland, for originally approaching me with the idea for this book and for encouraging me, supporting me, and holding my hand along the way. My gratitude extends to my whole book team at Ten Speed Press for their expertise and encouragement throughout the entire writing, editing, and publishing process.

I'm also thankful to my parents for encouraging my creativity and always believing in me; to my sister and my husband's family for their love and support; and to my close friends for stepping up and helping us with childcare and the boys' activities during the very busy months that I worked on crafting, photographing, and writing the tutorials for each letter. I am very thankful to be surrounded by a community of friends who not only accept me for my crazy-crafting-decorating-housie ways but also embrace it and care for me during the ups and downs of life.

Finally, in particular, I offer the utmost gratitude to my loving and supportive husband, Aaron, and my boys, Leif and Finn, for their understanding, patience, and belief in me as I pursued and continue to pursue my creative passions. Their unfailing support was key as I embarked on adding this enormous task to our already very busy lives and, without them, my life would not be so full and sweet.

about the author

KRISTA AASEN is the creator of the popular DIY, décor, craft, and lifestyle blog *The Happy Housie*. She lives with her husband and two school-aged boys in a cozy and bright lakefront home on Vancouver Island, British Columbia, Canada. In between teaching elementary school and ferrying her boys to their multiple sports and activities, Krista squeezes in time to enjoy all house-related pursuits. From renovating houses, making over vintage furniture, sewing new pillow covers, and organizing every space in her home to creating new wreaths and garlands to decorate for the season, no project is too big or too small. She and her projects have been featured in *Woman's Day, Country Woman* magazine, BetterHomesandGardens.com, *The Home Depot Blog, Just a Girl and Her Blog, House of Turquoise,* and *Savvy Southern Style*.

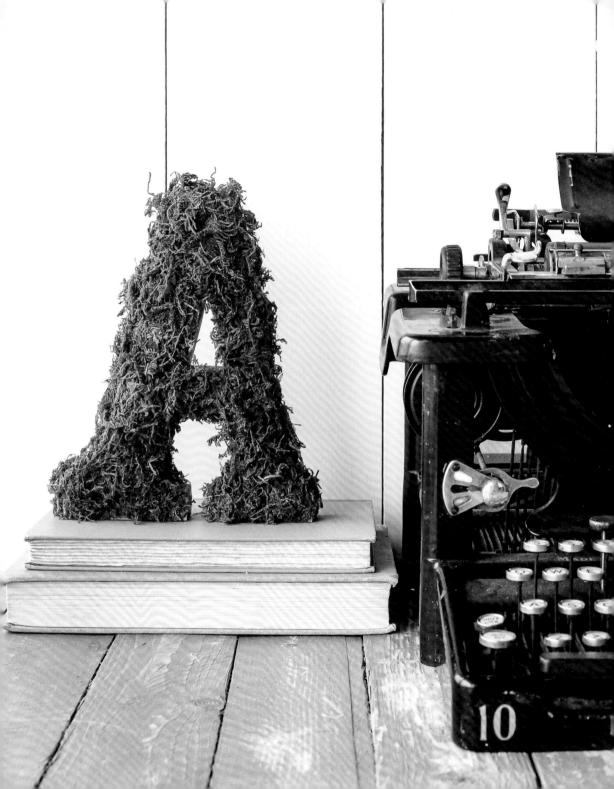

index

W

Text and photographs copyright © 2018 by Krista Aasen

Published in the United States by Watson-Guptill Publications, an imprint of the
Crown Publishing Group, a division of Penguin Random House LLC, New York.
www.crownpublishing.com
www.watsonguptill.com

WATSON-GUPTILL and the HORSE HEAD colophon are registered trademarks
of Penguin Random House LLC

Library of Congress Cataloging-in-Publication Data is on file with the publisher.

Trade Paperback ISBN: 978–0–399–58108–3
eBook ISBN: 978–0–399–58109–0

Printed in China

Design by Hope Meng

10 9 8 7 6 5 4 3 2 1

First Edition